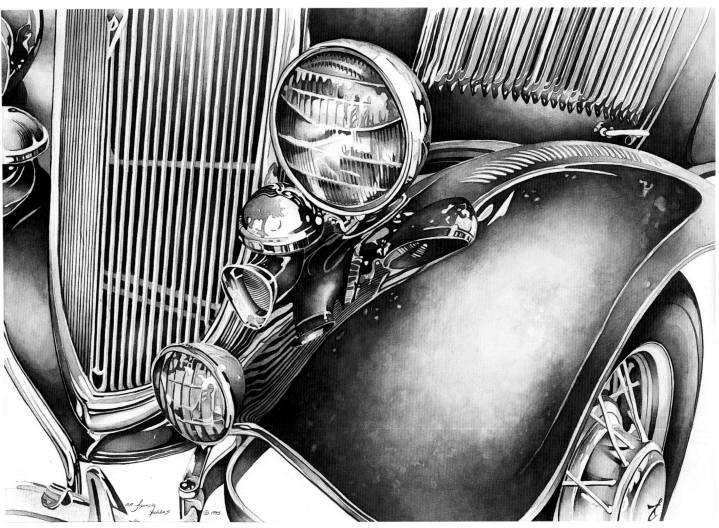

CLASSIC FORD #2 Mary Anne Lipousky Butikas, 11.75" x 17" (30cm x 43cm)

splash 6

THE MAGIC OF TEXTURE

I have a preference for vintage model cars, from a time when aerodynamics took a back seat to durability, style and artistic design. To look deep within the massive chrome grills and reflective convex surfaces is like stepping through the looking glass.

—Mary Anne Lipousky Butikas

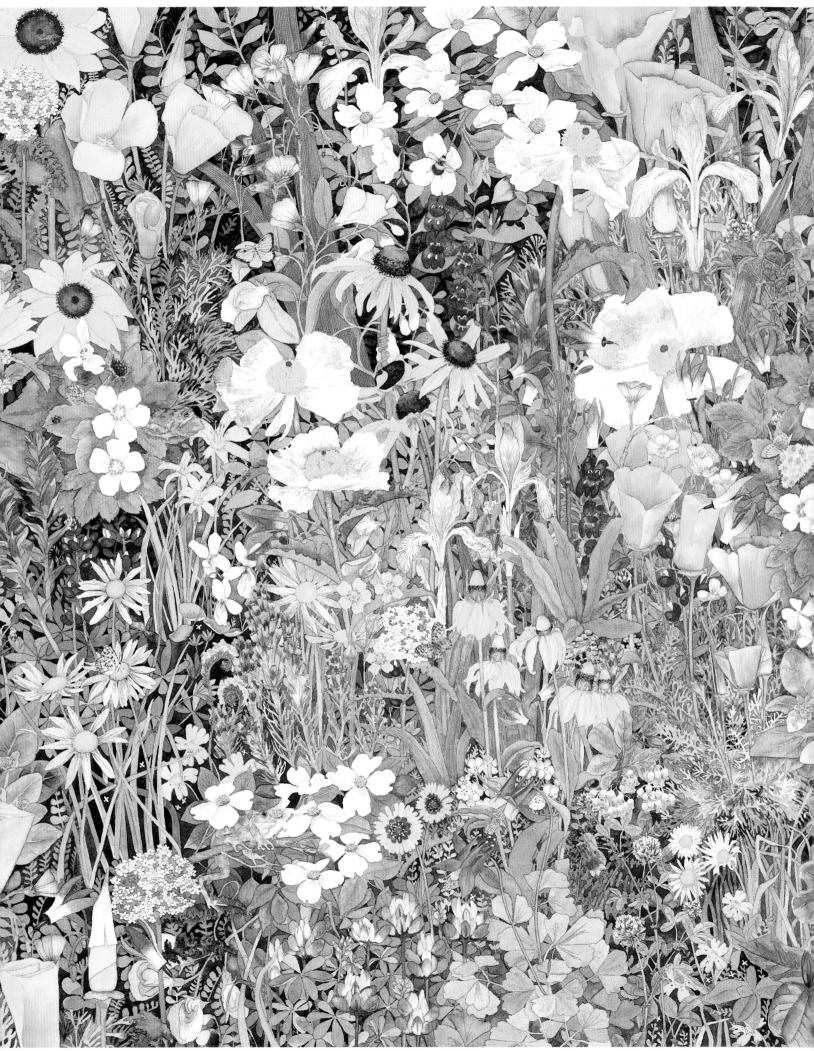

WILDFLOWER TAPESTRY Bambi Papais, 22" x 30" (56cm x 76cm)

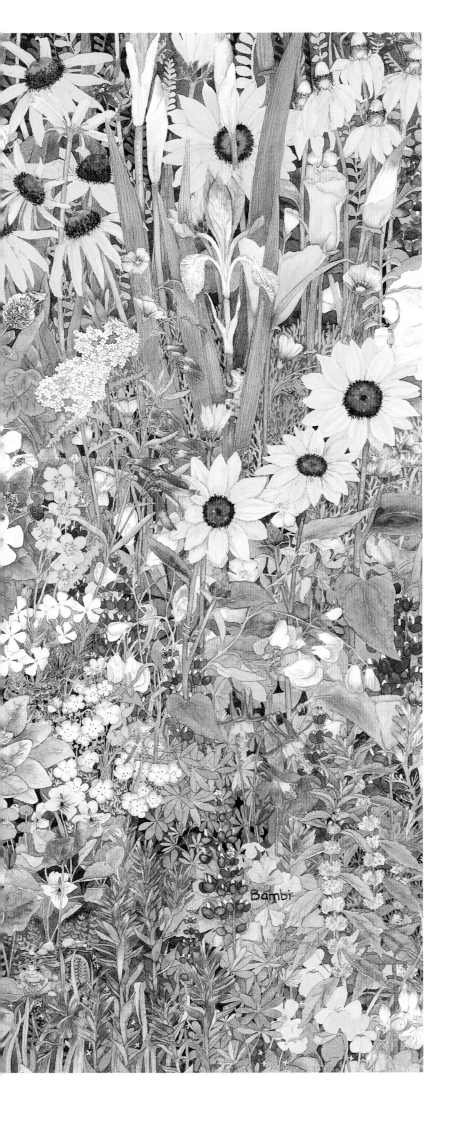

splash 6

THE MAGIC OF TEXTURE

The idea for *Wildflower Tapestry* came to me while I was walking through an incredible area of wildflowers. When I tried to concentrate on one flower, the intense colors of flora and fauna seemed to make my eyes ramble on to the next flower and continue until I had lost the first flower I was looking at. It was this natural spontaneity with nature that I wanted to capture with watercolor.

—Bambi Papais

NORTH LIGHT BOOKS

CINCINNATI, OHIO

WWW.NLBOOKS.COM

EDITED BY RACHEL RUBIN WOLF

Rachel Rubin Wolf is a freelance writer, editor and artist. She has edited many fine art books for North Light, including the *Splash* watercolor series; *The Best of Wildlife Art* and *Best of Wildlife Art 2; The Best of Portrait Painting;* and *Best of Flower Painting 2.* She is also the author of *The Acrylic Painter's Book of Styles & Techniques; Painting Ships, Shores and the Sea;* and *Painting the Many Moods of Light* (all from North Light).

Wolf studied painting and drawing at the Philadelphia College of Art (now University of the Arts) and the Kansas City Art Institute, and received her B.F.A. from Temple University in Philadelphia. She resides in Cincinnati, Ohio, and continues to paint in watercolor and oils as much as time permits.

≈ Thanks again to the talented editors and staff at North Light Books who helped organize the myriad details of this book, including Mary Dacres, Jolie Lamping, Stefanie Laufersweiler and Amber Traven.

Most of the works in this book were painted with transparent watercolor alone; however, some of the artists creatively combined watercolor with other mediums. The legends note when these artists used mixed media.

Splash 6: The Magic of Texture. Copyright © 2000 by North Light Books. Manufactured in China. All rights reserved. No part of this book may be reproduced in any form or by any electronic or mechanical means including information storage and retrieval systems without permission in writing from the publisher, except by a reviewer, who may quote brief passages in a review. Published by North Light Books, an imprint of F&W Publications, Inc., 1507 Dana Avenue, Cincinnati, Ohio, 45207. (800) 289-0963. First edition.

Other fine North Light Books are available from your local bookstore, art supply store or direct from the publisher.

04 03 02 01 00 5 4 3 2 1

Library of Congress Cataloging-in-Publication Data
Splash 6: the magic of texture / edited by Rachel Rubin Wolf.
 p. cm.
 Includes index.
 ISBN 0-89134-960-X (alk. paper)
 1. Watercolor painting—Technique. 2. Texture (Art). I. Title: Splash six.
 II. Title: Rubin Wolf, Rachel, 1951–
ND2365 .S66 2000 99-045771
751.42'2—dc21 CIP

ISBN 0-89134-349-0 (1), ISBN 0-89134-503-5 (2), ISBN 0-89134-561-2 (3),
ISBN 0-89134-677-5 (4), ISBN 0-89134-904-9 (5), ISBN 0-89134-960-X (6)

Editors: Rachel Rubin Wolf and Stefanie Laufersweiler
Cover and interior designer: Amber Traven
Interior production artist: Joy Morell
Production coordinator: Kristen Heller

The permissions on pages 138-140 constitute an extension of this copyright page.

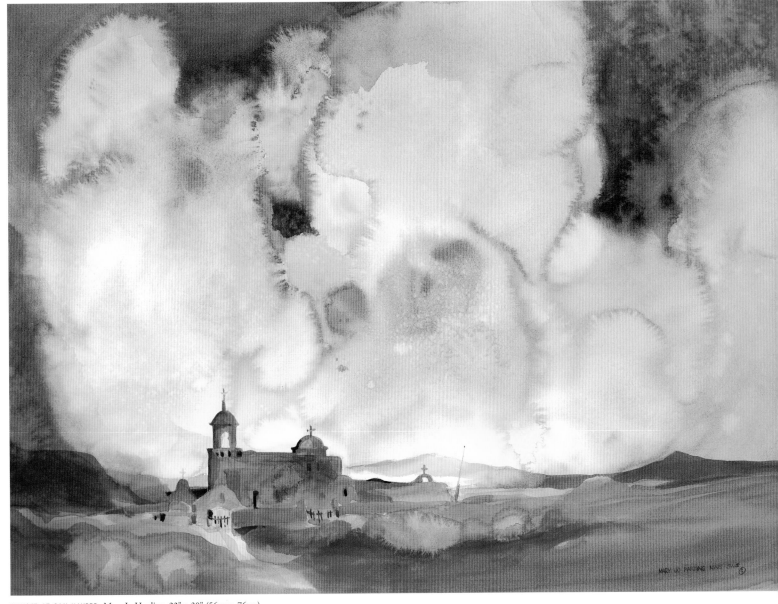

SUNSET AT SAN XAVIER Mary Jo Harding, 22" x 30" (56cm x 76cm)

To the many generous artists who have shared their work with us: You have enriched the texture of our lives by doing so. To the artists whose work appears in this book: Thank you for all of your cooperation in carrying out the tasks to complete this book, especially for the cheerfulness with which they were performed.

San Xavier del Bac is one of the most beautiful of the Spanish missions in the Southwest. I painted it in the pinks and reds of the southern Arizona desert, with the mission backlit by the glowing sunset. To dramatize the expanse of the western sky and the jewel-like quality of the clouds, I placed the mission very small against the large sky, giving me the freedom to use backruns to explore the texture.

—*Mary Jo Harding*

Introduction *pg 8*

Epigraph *pg 10*

Contributors *pg 138*

Index *pg 141*

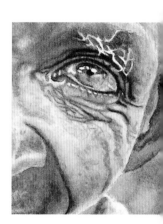

inspired by the textures of **nature**
pg 32

rendering smooth and **reflective** textures
pg 12

delighting in the textures of **color** and pigments
pg 54

4

portraying the textures of **people** and animals

pg 72

6

disclosing the textures of the **spirit**

pg 108

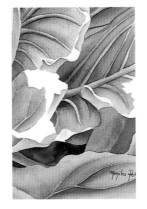

5

conveying the textures of **light** and weather

pg 92

7

depicting a variety of **manmade** textures

pg 122

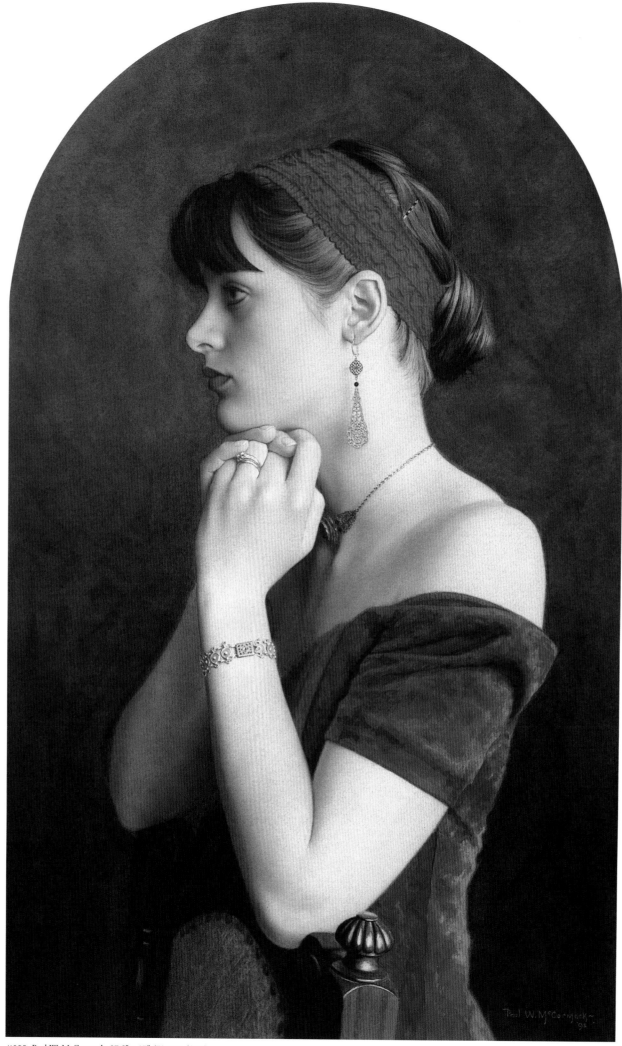

HOPE Paul W. McCormack, 27.5" x 17" (70cm x 43cm)

In this, our sixth edition of *Splash,* we were aware that we could rest on our laurels, kick back and let our previous successes lure us into complacency… same old, same old. However, as the production staff at North Light will attest, this editor never likes to do the same thing twice. It makes the people who have to balance the ledger a bit nervous sometimes, but it keeps life interesting.

So we decided to highlight texture in this edition because, over the years, we have found that it is a particular interest of watercolor artists. Perhaps it is because watercolor is adaptable to so many different applications. Some of our artists get turned on by the very textures one can create from the paint itself. Endless variations. Others are fascinated by the infinite world of natural textures and seek to replicate these in some way for our better appreciation of them. Still others seek to reveal the sometimes beautiful, sometimes ugly side of textures that we as humans have added to the fabric of this earth. Some of our contributing artists make visual a very personal texture that creates a mood or spiritual feeling. All of these are valid interpretations.

Some words that can define texture are: surface quality, feel, character, composition, weave, personality, nature, makeup and appearance. All of these and more are represented here. We hope the *Splash* series continues to give you inspiration and pleasure.

—*Rachel Rubin Wolf*

Making my living primarily as a portrait artist, it is always an extreme pleasure when I can afford the time to paint something for myself. *Hope* was inspired by my wife when she took this pose next to a north-lit window. The contrast in texture of the velvet dress against her skin was an added plus to this already striking pose.

—*Paul W. McCormack*

Art is the difference between seeing and just identifying.

–Jean Mary Morman

39¢ A LB. Beth Patterson, 13" x 18.75" (33cm x 48cm)

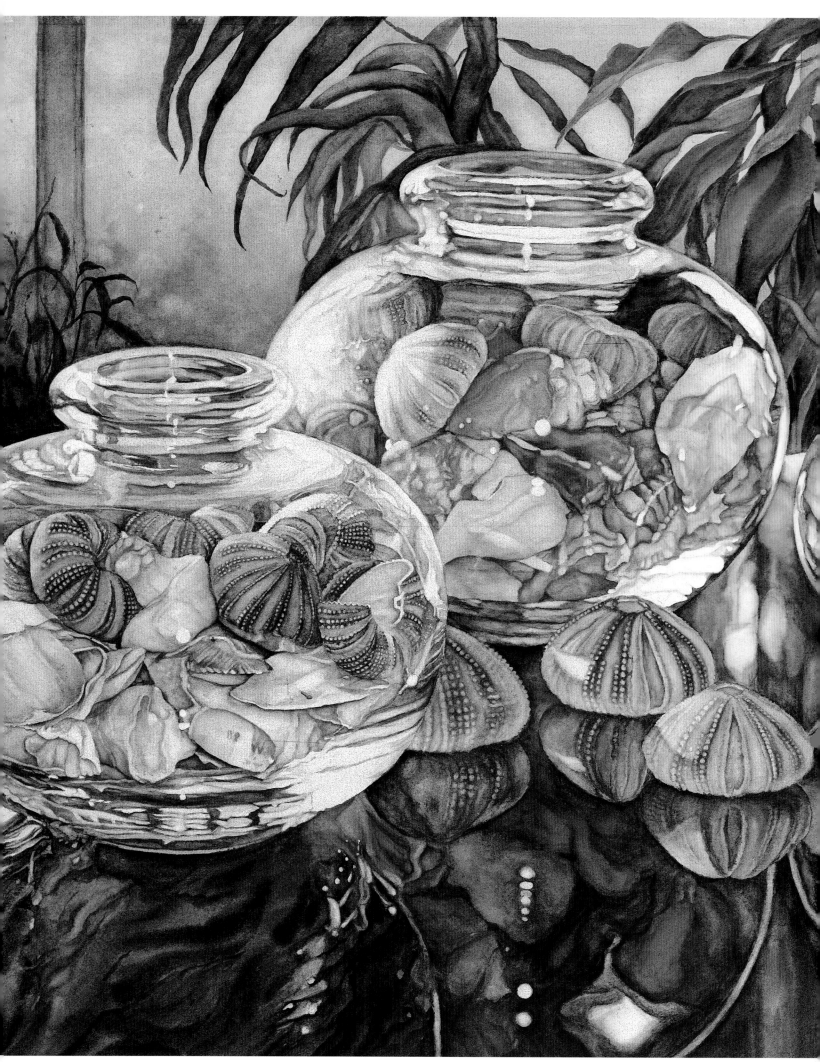

REFLECTIONS Elaine Hahn, 22" x 30" (56cm x 76cm)

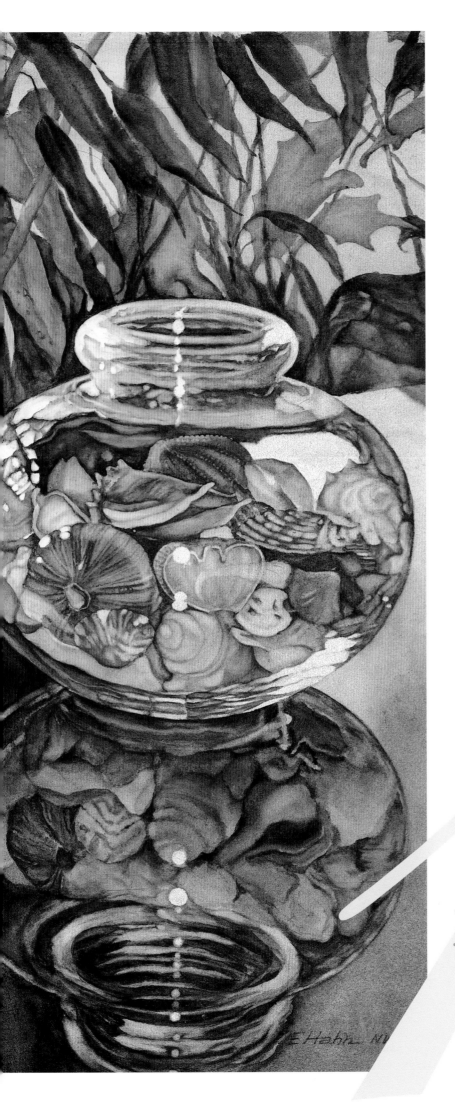

Reflections is about how natural, free-flowing shapes and textures in shells and sea life intermingle with the rigid, firm shapes made by man. The hard, clear reflective surface of the glass table was a great contrast to the irregularity and rough texture of the shells and sea urchins. The symmetry of the glass bowls and their reflections on the table added another dimension, creating a very challenging composition. As I paint, I focus on one small area at a time, looking closely at the color and textures to be rendered. As I work from area to area, the textures transform with the need to bring out one or another as the painting develops.

—Elaine Hahn

rendering smooth and

reflective

textures

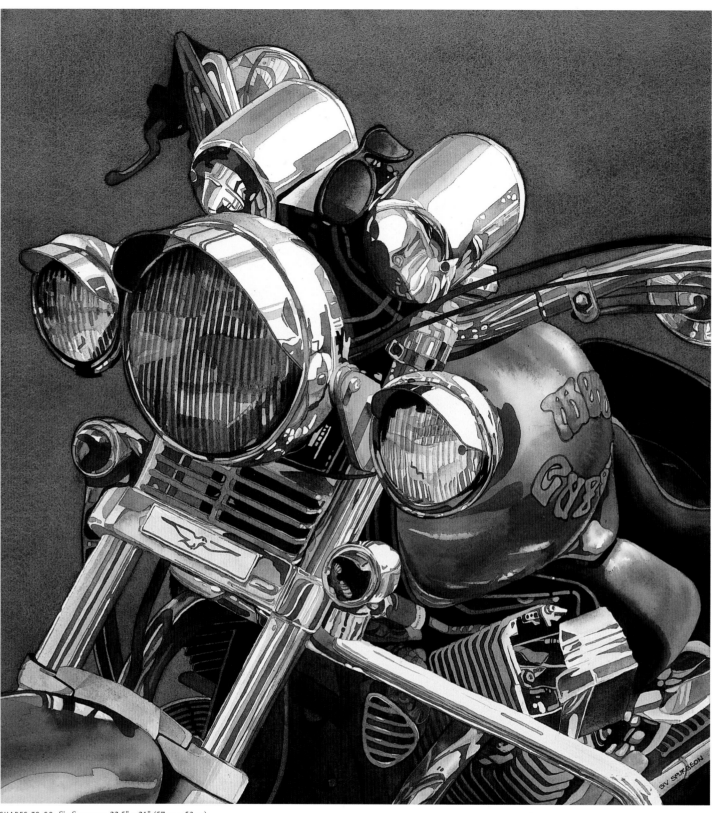

SHADES TO GO Siv Spurgeon, 22.5" x 21" (57cm x 53cm)

Break Complex Reflections Into Small Shapes

SIV SPURGEON

Whenever I paint something complex, I spend a lot of time studying the subject. Here, I paid special attention to the reflections in the chrome—their placement, shapes and colors. When painting highly reflective surfaces, rely on your observational skills. On a motorcycle, with chrome at many different angles, color is repeated in the most unexpected places. You have to believe your eyes, even if it does not appear to make sense, because when the painting is done, it works. ⁓ Antwerp Blue is one of my favorite pigments. It sort of explodes when you drop it onto wet paper, even when mixed with a bit of Sap Green, as seen here. The effect was particularly useful in painting the gas tank—the pigment itself did half the job. I masked out the Moto Guzzi logo before painting the tank, but used no other masking. Large, overexposed color copies of my reference photos allowed me to see hidden details, which was helpful when painting the areas in shadow.

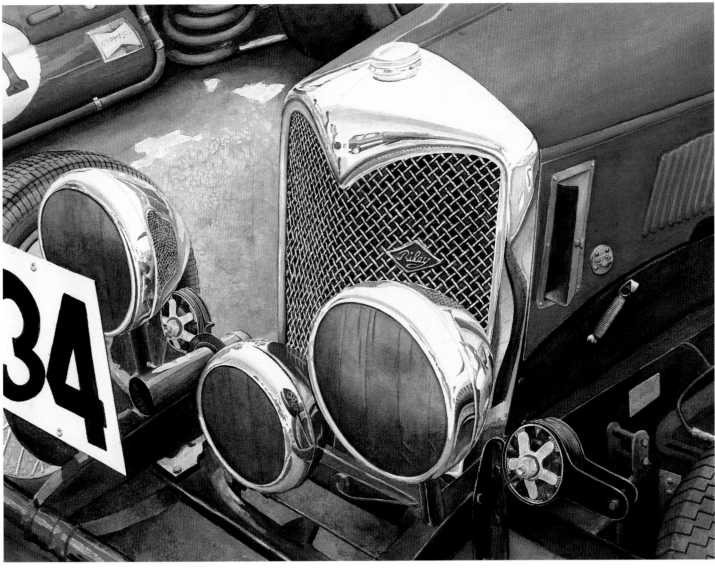

TRICLOPS Garland Rush, 22" x 30" (56cm x 76cm)

Don't Paint Chrome, Paint Reflections

GARLAND RUSH

The original photo for this painting was taken because I had never seen a woven steel grill before and wanted a shot for reference. After seeing the picture, I wanted to paint it all, but was stuck on how to capture the look of chrome. After studying the photograph, it finally dawned on me that you don't paint chrome; you paint the reflections in it. On a painting like this, I work from the reference photo with a magnifying glass to capture as much detail as possible. Only one change was made from the photo: The car originally was white, and I thought it needed more contrast with the chrome. For the curious, the headlights are taped over to keep glass off the racetrack in case of breakage.

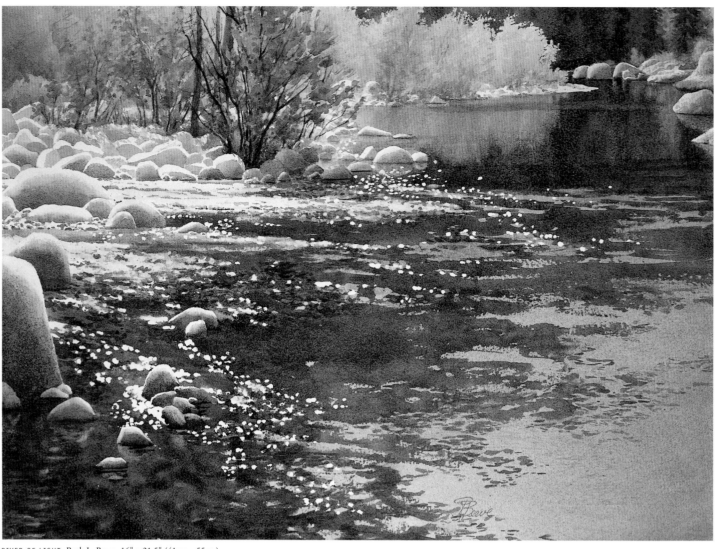

RIVER OF LIGHT Ruth L. Beeve, 16" x 21.5" (41cm x 55cm)

⚘ Combine Wet-in-Wet and Hard Edges for Water

RUTH L. BEEVE

Capturing the surface texture of water is an interesting challenge because it changes dramatically from morning till night, even from minute to minute. In *River of Light*, I wanted to express the sheer brilliance of an October afternoon on the banks of the south fork of the Yuba River in California. ✺ I used transparent, non-staining pigments to combine on the paper, wet-into-wet, to form interesting textures—as in the reflection in water of the trees and the suggestion of shadows under the water in the left foreground. In other places a hard-edged technique was used to show the sparkle and movement of the water. The darker areas were applied in a curving pattern from top right to bottom left, giving the painting a strong underlying structure of values. Maskoid was used to preserve whites in the rocks and the sparkles on the water.

➵ Majestic Smooth Stone in a Soft Atmosphere

DERWIN ABSTON

I was inspired by the quiet majesty of this grand space. There were many textural challenges in the execution of the painting. One was to portray the essential nature of the column capitals and arches without getting overly complex. Another was to show the smoothness of the column shafts while also capturing the subtle patterns on their surfaces. Finally, painting the softer and less-defined atmosphere of the background and areas at the floor proved the most challenging. ✺ After completing the drawing, I used masking to protect the highlight on the column. Many washes in layers of Yellow Ochre, Raw Sienna, Permanent Magenta and Ultramarine were used to capture the softer nature of the background and to establish the proper value range.

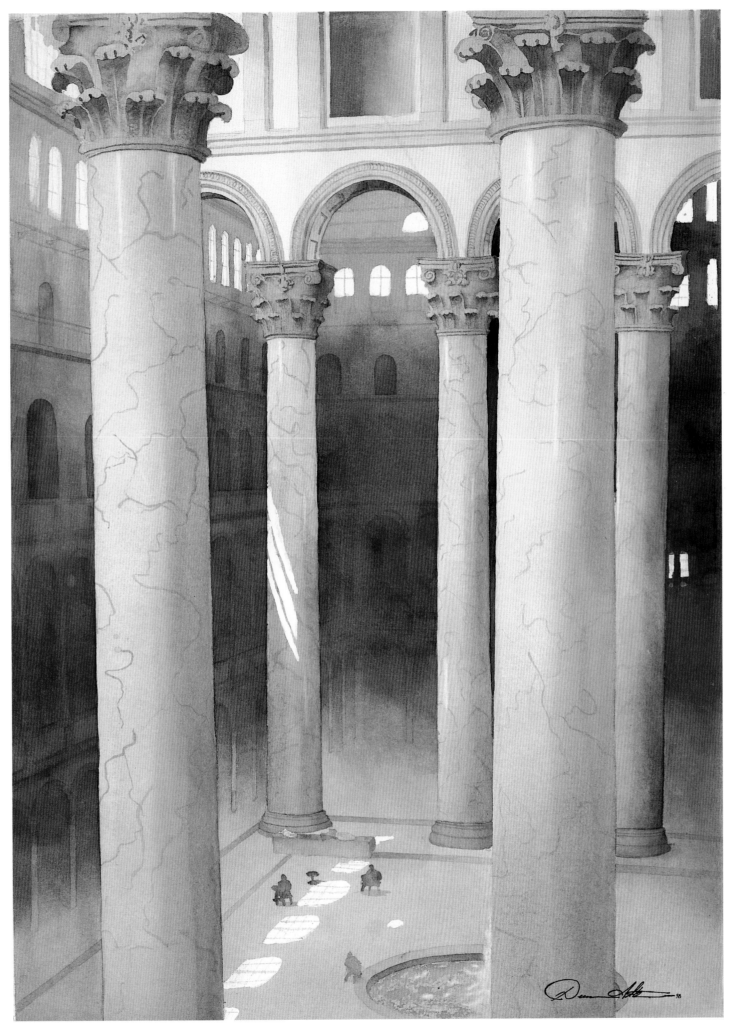

PENSION BUILDING Derwin Abston, 30" x 22" (76cm x 56cm)

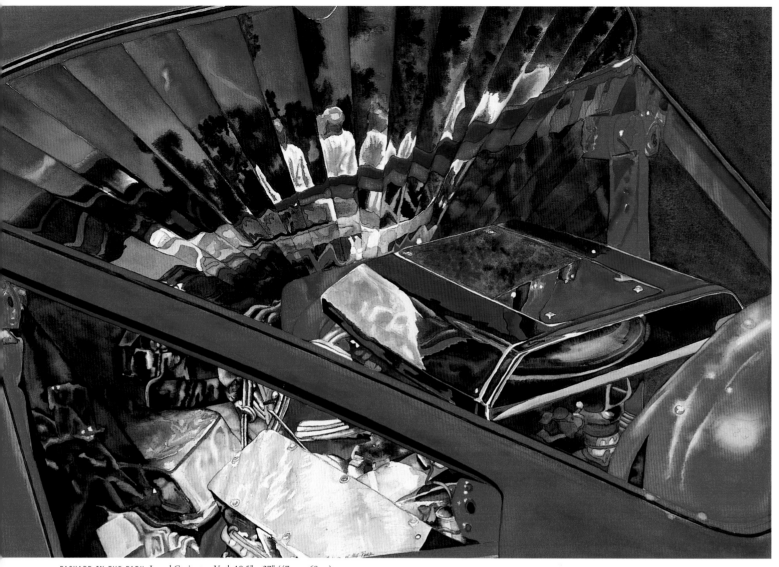

PACKARD IN THE PARK Laurel Covington-Vogl, 18.5" x 27" (47cm x 69cm)

Reflective Metal in Complementary Colors

LAUREL COVINGTON-VOGL

While viewing a collection of classic cars at a local park, I was attracted to a brilliant red Packard parked on the green grass. The engine interior had a highly polished, pleated-chrome fire wall that reflected, fractured and abstracted everything around it. The challenge was reproducing the reflective qualities of metal while working with a red-and-green complementary color scheme. Both warm and cool reds were used in the direct painting of the Packard, while Phthalo Green and Alizarin Crimson mixtures provided the grays used on the chrome. Mixing complements creates a wide variety of grays that can be adjusted toward warm or cool. I just slightly mix the two colors together so that the pigments will separate into wet-in-wet mixtures. This adds extra vibrancy and shimmer.

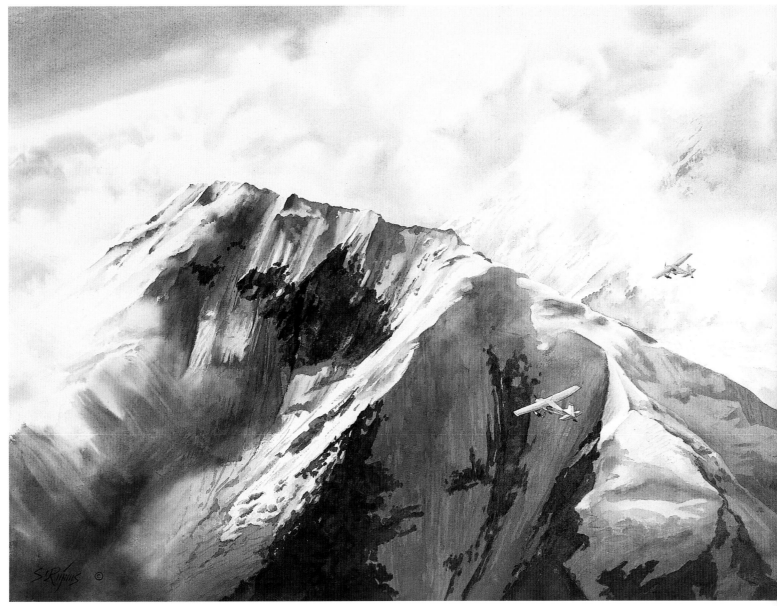

FLAVOR OF ALASKA Sharon Rajnus, 22" x 30" (56cm x 76cm)

A Land of Ice, Snow and Sky

SHARON RAJNUS

Unusual location was the challenge in *Flavor of Alaska*. The incredible color of the rugged country called out to be painted, and all the structure needed to carry it off seemed to be there: the ridges, the rock, the drifted snow. It called for a combination of watercolor techniques: both soft edges (wet-in-wet) and detail (drybrush) to capture atmosphere, light and place. ✍ I masked nothing in the painting except the nearer airplane. I attempted to create "atmosphere" under and around the plane, so it would seem to be passing over the darker value of the ridge beneath. I wet sections of the paper as I worked, allowing the color to flow for the soft edges and controlling the mix by the amount of water.

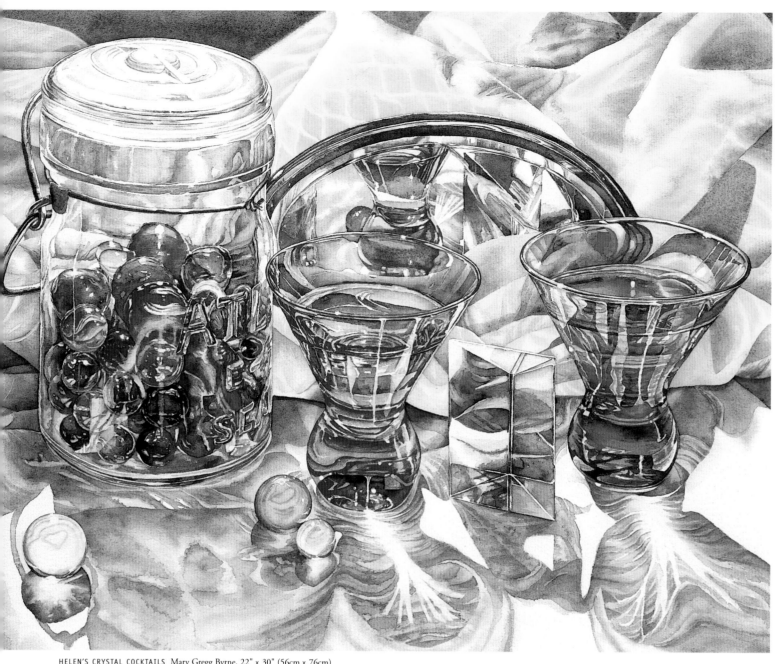

HELEN'S CRYSTAL COCKTAILS Mary Gregg Byrne, 22" x 30" (56cm x 76cm)

Show Texture Contrasts by Painting Style

MARY GREGG BYRNE

Most of the textures depicted in *Helen's Crystal Cocktails* are hard, glassy reflective surfaces. These textures continue layer upon layer in the glass jar filled with marbles and beach stones. The hard surfaces of crystal, glass and mirrors are contrasted by a soft fabric background and a diffusely patterned foreground of light and color reflecting off and through the glass. I tried to emphasize this contrast by painting the fabric and shadows with a looser, wet style and the glass objects with crisp, dry detail. ✑ I used a wide variety of brushes and a palette of about ten different colors, with a Sepia-and-Indigo mix for the darkest darks and neutral shadows. White highlights are important in making glass look like glass, so I use frisket to preserve them while I paint freely within the glassy surface texture.

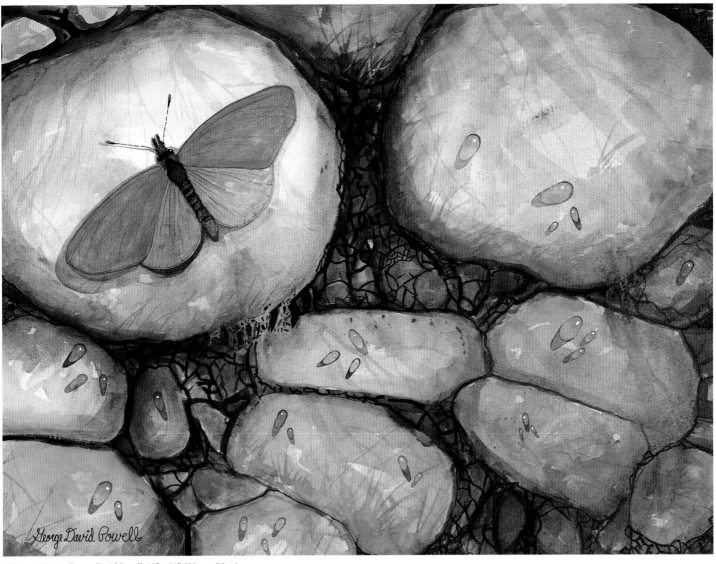

TOO WET TO FLY George David Powell, 22" x 30" (56cm x 76cm)

Dramatic Texture Holds the Eye

GEORGE DAVID POWELL

In *Too Wet to Fly*, the perspective is looking down at water running over the small stones in a creek bed. Glazes of blue and purple give the rocks a luminous quality, and highlights on the larger rocks work with the drops of water to achieve a wet texture. Glazing cast shadows over the painting gives depth and shadow. An enticing feature of the scene was the contrast of the blue insect with transparent color, its wings too heavy to fly. ✍ I mixed Payne's Gray with Ultramarine Blue, painting the small cracks as I went. At the bottom edge of the larger rocks I loaded my brush with paint, tilted the paper and let it run freely, creating the effect of running water.

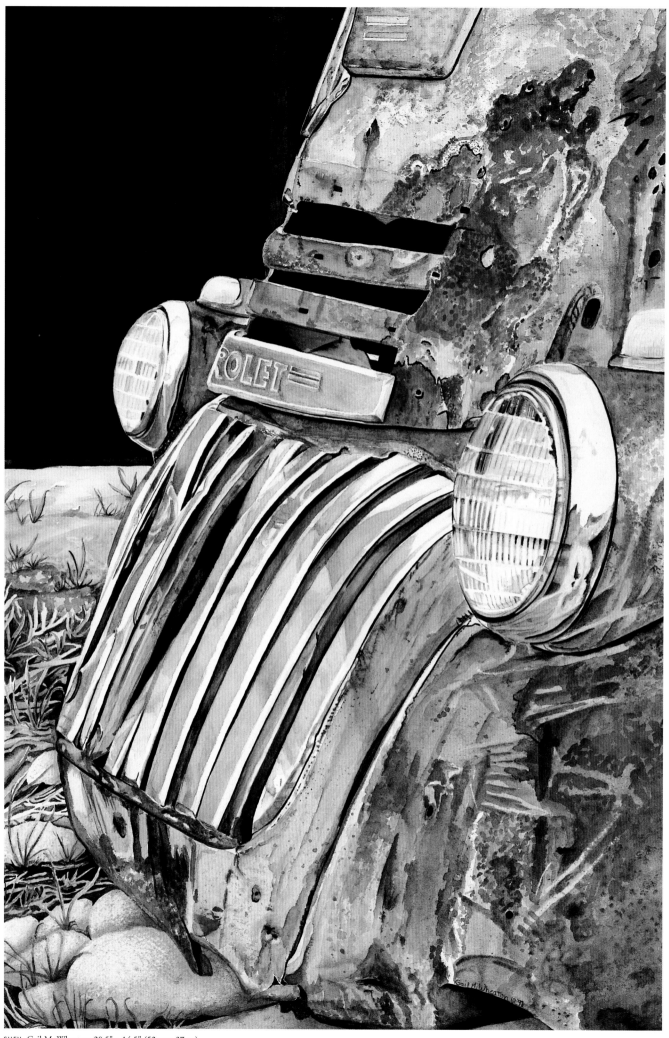

CHEV Gail M. Wheaton, 20.5" x 14.5" (52cm x 37cm)

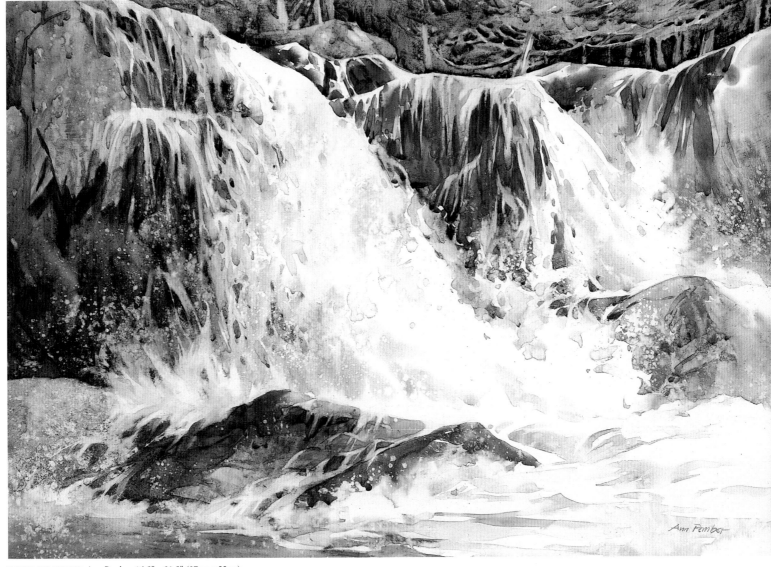

TURBULENT WATERS Ann Pember, 14.5" x 21.5" (37cm x 55cm)

☀ Try Gessoed Paper for Interesting Textures

ANN PEMBER

This surface is perfect for capturing the nature and textures of the streams and rocks so abundant in the Adirondack Mountains. It allows lifting back to white easily. You can spray a wash with water and lift the color where the droplets fall, giving the effect of water spraying on rocks. Many layers can be painted without loss of freshness. With the board tilted at forty-five degrees or more, movement is maximized. Spraying wet washes with water or paint really makes them mingle and flow. ◦ৎ I began with an even coating of gesso, just enough to coat the surface. Once it was dry, a simple drawing was made with a rigger brush and Raw Umber. This is easily lifted or painted over; pencil would damage the surface. With a flat brush, the painting was built up with layers of pigment. It is a tricky process: If you touch the surface more than once while it's wet, you will lift paint off.

◄ Surface Disintegrates With Splashes of Color

GAIL M. WHEATON

Objects in a junkyard offer unlimited opportunities to explore the transparency of watercolor. Oxidation of metal causes beautiful patterns of color as it eats its way up from the metal through the base-coat color to the top layer of paint. ◦ৎ Drybrush was used to dot and drag the color on with my favorite rust color combinations of Brown Madder, Burnt Sienna and Yellow Ochre. The rocks were painted with glazes of color and then erased with an abrasive, ink-erasing pencil to bring out the texture of stone. All of the white in the painting is the white of the paper.

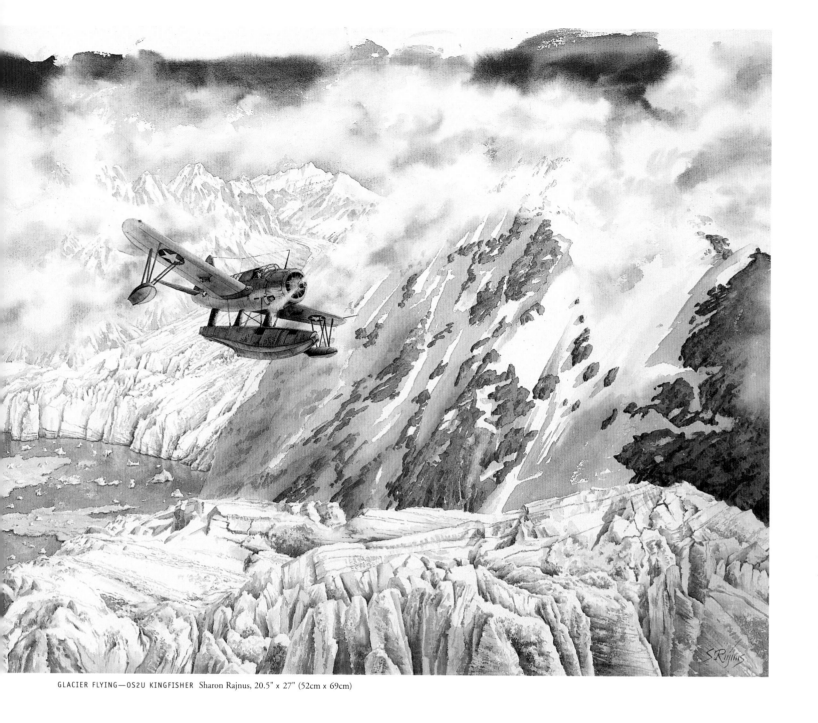

GLACIER FLYING—OS2U KINGFISHER Sharon Rajnus, 20.5" x 27" (52cm x 69cm)

Paint the Textures of Our Planet

SHARON RAJNUS

Glaciers, with all their crevasses, size, color and texture, hold a fascination far beyond what we experience in our daily lives. Glaciers can be immense in scope, rugged in definition, intoxicating in color. The infinite variety of the ice flows as seen from our small plane was the perfect set of building blocks from which to build a series of paintings. ✍ I begin with small thumbnails to determine composition; in a watercolor like this, careful planning is the best approach. Planning light against dark, dark against light, is an effective method. But not all of the painting is detailed or it would become too busy. I planned soft edges, such as in the sky, to contrast with the texture of the glacier.

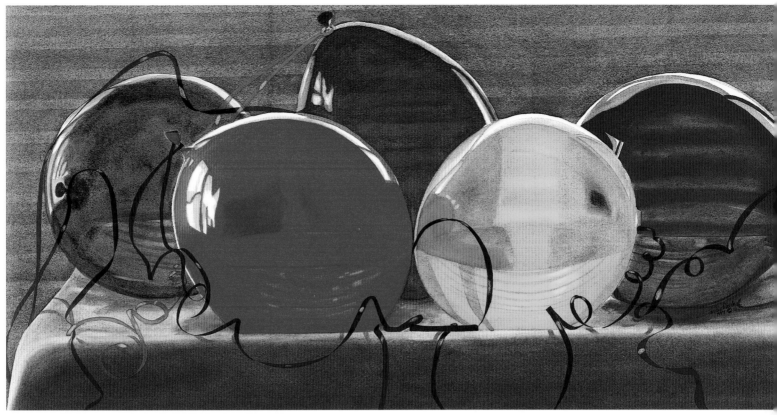

WATER BALLOONS II Carol Black, 14.5" x 29.5" (37cm x 75cm)

The Complexity of Simple Forms

CAROL BLACK

Having spent twelve years working in biology—and in raising my two children—I have learned to view the world differently. The way the simple image of these water balloons contrasted with the complexity of their attributes—their transparent surfaces, overlapping colors and the heaviness of the water inside—fascinated me. These properties all reflect light in different ways. Adding water to the balloons intensified the concave distortions and added more texture of wetness. The basic colors helped to unite the balloons with the lighting and to emphasize the patterns and texture of the blinds through the water. ◦ To balance the composition, I placed the objects within a grid on the paper. Then I penciled around the white areas and painted wet-into-wet, leaving penciled areas dry. I began a slow process of glazing to create the illusion of the luminous, smooth surface of the balloons. I was mindful of reproducing the properties of the water's weight and the tentative containment of that water. The opaque texture of the ribbons was created through wet-on-dry painting and color lifted to cause the surface reflections.

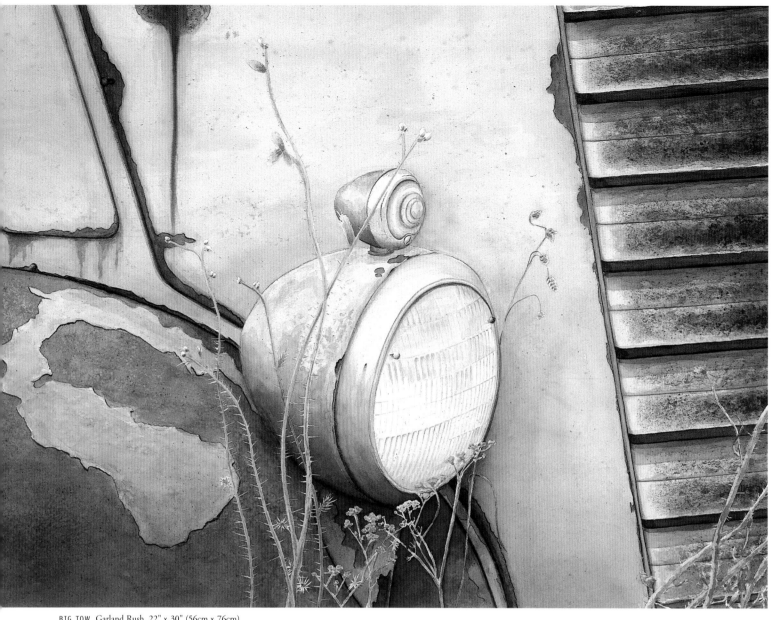

BIG TOW Garland Rush, 22" x 30" (56cm x 76cm)

Wash and Salt for Rust

GARLAND RUSH

Working from photographs occasionally provides me with surprise subjects for paintings. I usually take a shot of the whole intended subject, and then zoom in on specific areas that I might need for reference later. This painting came from one of those pleasant surprises. As soon as I saw this image, I knew I had to paint it. The combination of textures—oxidized and peeling paint, rust, tarnished chrome, prickly weeds, and the glass of the headlight, seemingly untouched by time—was irresistible. ✺ I always start with a detailed pencil drawing, even shading in the dark areas to get a feel for where I'm headed. The weeds were liquid masked and left until the end, as were the glass and chrome of the lights. The green was built up from numerous thin washes, with some blotting along the way with a paper towel. Rust on the body was made with many applications of wash and salt; I let the wash dry to the damp stage so the salt would lift tighter areas of pigment. Since the grill was pitted with rust instead of covered by it, I used spatter and drybrush to capture the look.

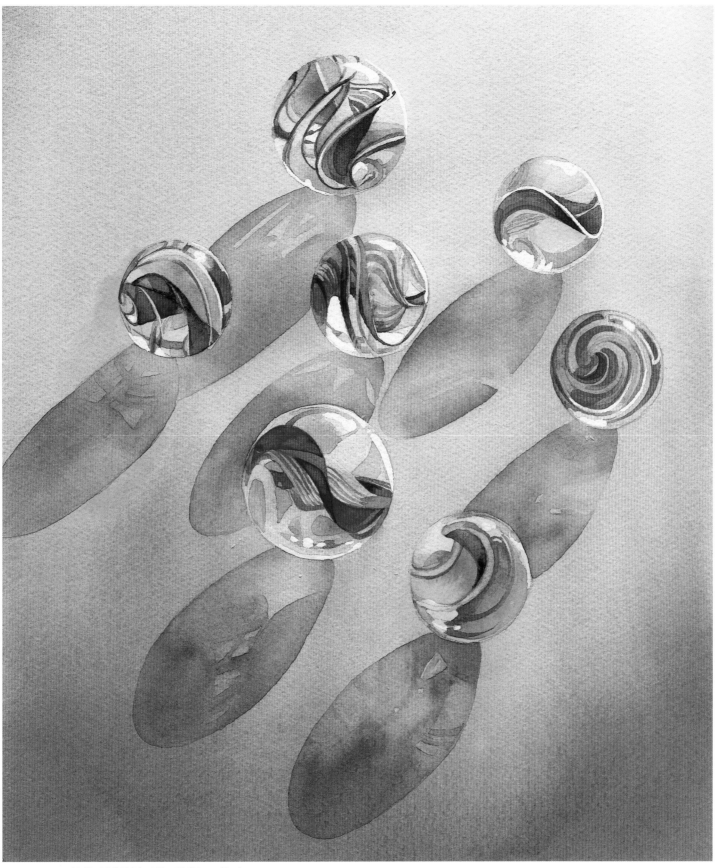

LOST AND FOUND Marlies Merk Najaka, 26" x 19" (66cm x 48cm)

Find Color in "Transparent" Shadows

MARLIES MERK NAJAKA

These marbles were evocative of my childhood, and I liked their repetitive circular shapes. I am also intrigued with shadows cast by "transparent" objects and the interplay of reflected colors. ✍ I always begin by laying down a series of washes, allowing the paint to blend while the paper is wet. I begin loosely and proceed to add detail. I like to amplify the colors I find in the shadows.

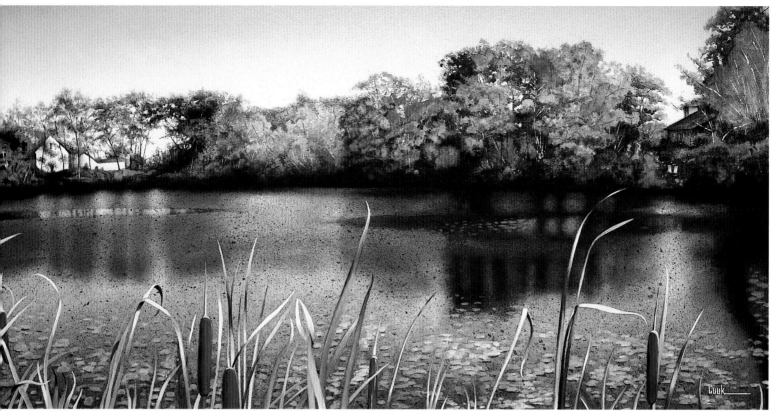

AUTUMN SYMPHONY George E. Cook, 9.5" x 18.75" (24cm x 48cm)

⇕ A Traditional Approach

GEORGE E. COOK

Since I am a fugitive from commercial and industrial art, in which much of the work has to be very precise, that tendency toward detail flows over into my watercolors. ⮷ *Autumn Symphony* was completed almost entirely with transparent watercolor, with some opaque in just a few locations. Orange, Burnt Umber, Raw Umber, Permanent Red, Vermilion, Indian Yellow, Ultramarine Blue and some Hooker's Green were the colors used, and the brushes ranged from a no. 5 to a no. 1 to obtain the delicacy of the leafwork.

⇢ Optical Mixing for Water and Rocks

JAMES TOOGOOD

The coast of Bermuda has a variety of contrasting natural textures. But to create both the sharp, jagged rocks and the flowing sense of depth and movement in the water, I use a very similar technique: optical mixing. Rather than actually mixing pigments on the palette, I let them blend visually on the paper either by glazing one over the other or by painting them side by side. ⮷ Optical mixing is especially effective when painting the natural fluidity and translucency of water. Rather than mixing yellow and blue on a palette to make green, I apply these colors in a series of clean washes, making sure the paint is dry before the next application. The result is brighter, cleaner and more complex because the light passes through each distinct layer of paint.

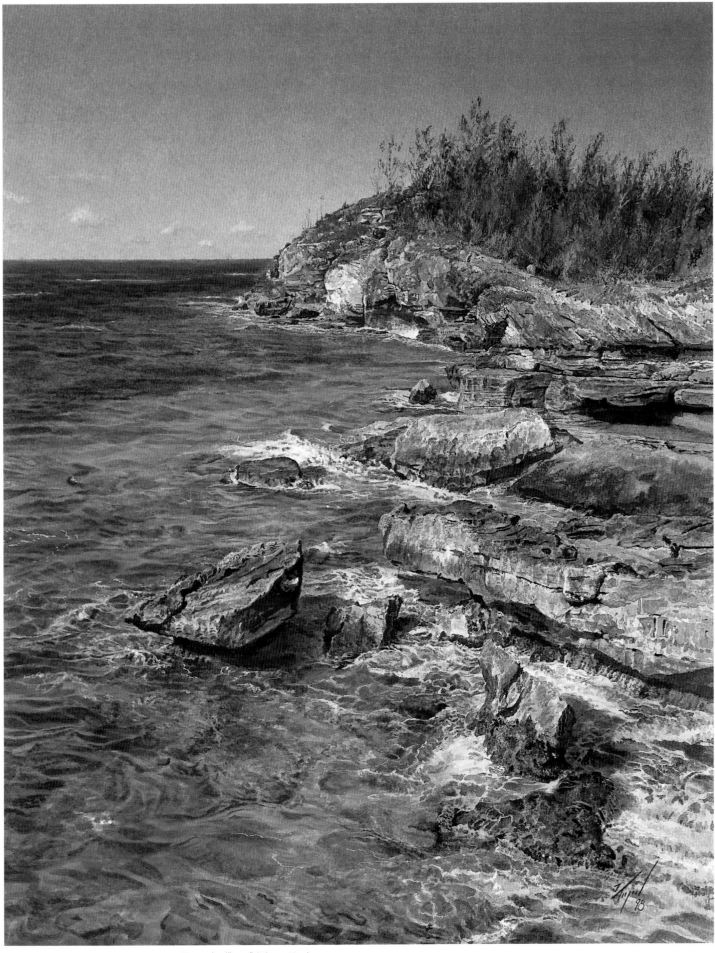

ROCKY COAST, SOUTH SHORE—BERMUDA James Toogood, 14" x 11" (36cm x 28cm)

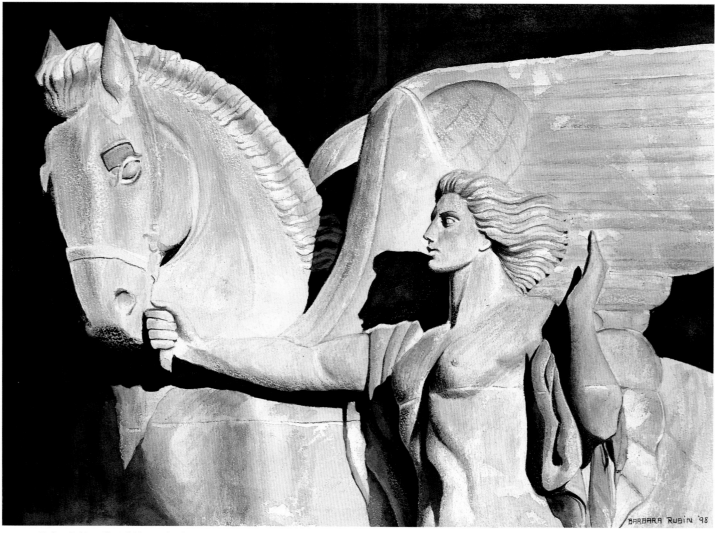

STATUE I Barbara Rubin, 19" x 27" (48cm x 69cm)

Wax Resist for the Texture of Rough Stone

BARBARA RUBIN

The challenge here was to transform the two-dimensional paper into a formidable three-dimensional subject of considerable bulk and roughness. A white wax candle, rubbed ever so sparingly in alternate layers with transparent paint, helped define the contours and give the illusion of rough stone. ✍ Using a candle as a resist medium to get the appearance of stone was fun and rewarding. I also like to pour an underpainting of washes of color before defining my objects. It lends a sense of vibrance and movement, especially to monochromatic subjects.

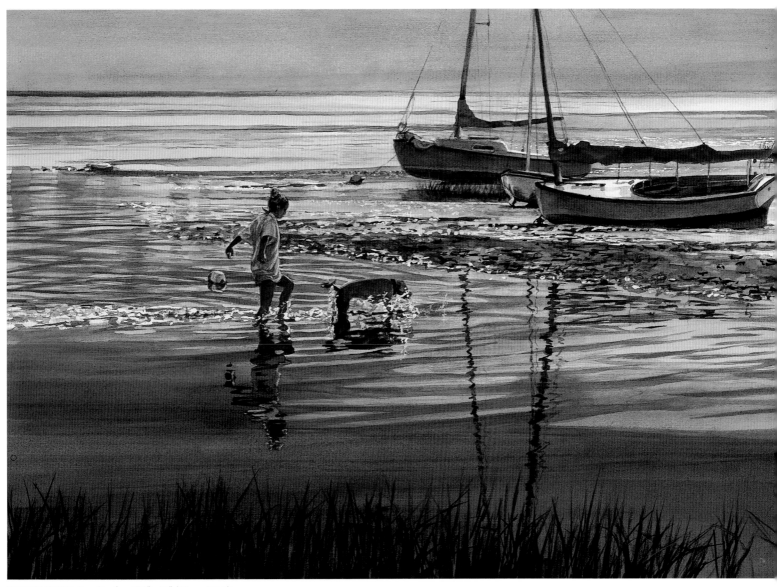

TRAILING SILVER Anne Boucher, 19.5" x 28" (50cm x 71cm)

Try a Smooth Surface for Color Intensity

ANNE BOUCHER

Dusk till sunset on Cape Cod Bay, especially at low tide, is an incredibly beautiful time. The locals know this, and when the beach crowd has left for the day, they savor this very quiet, still time, when color changes quickly from subtle to dramatic. The sparkle of the small rocks and the sheen on the shallow waters of the tidal flats work to set the peaceful mood of this late-summer evening. ✍

After careful drawing, I masked out important whites to save in the wake, boats and figures. I laid in a series of washes of Winsor & Newton Aureolin Yellow and Permanent Rose, working very quickly to underpaint both sky and water areas. The very smooth surface and brilliant white of Fabriano cold-press paper was ideal. Mixes of Cobalt Blue and French Ultramarine were used for the figures and the water, and to tone the sky. Intensity of color re-created the exact moment of dusk.

One year I was involved with a weekly, open-air arts-and-crafts market. I found that I really enjoyed painting in that setting, surrounded by fresh vegetables, flowers, crafts and other local artists. This painting was done almost entirely in my booth at our little market, among the shoppers, other vendors and curious onlookers (which is why I chose *Saturday Market* as its title). The entire composition was first underpainted monochromatically using Thalo Violet for all of the darks. Underpainting defined the individual textures of each of the vegetables. I glazed over the dried underpainting with New Gamboge to warm and gray the darkest shadows. Then I introduced the local colors to each area, further accentuating the textural depths. I reserved the highlights by painting around them and by lifting paint out in some areas.

— *Sally Cays*

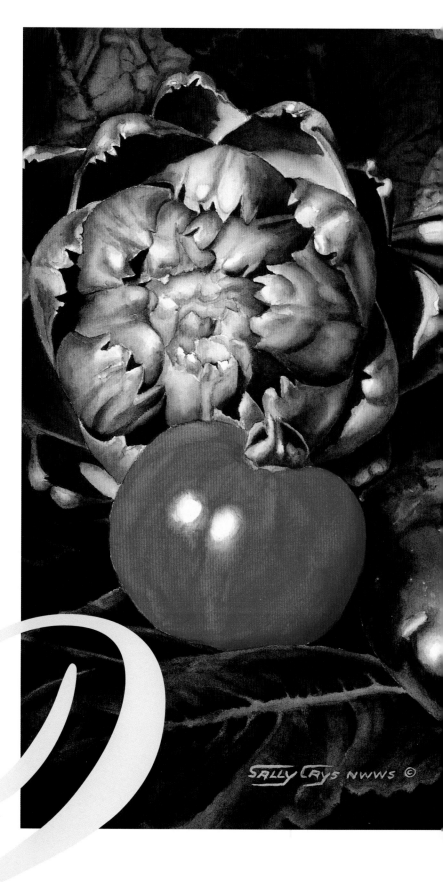

inspired by the

textures of **nature**

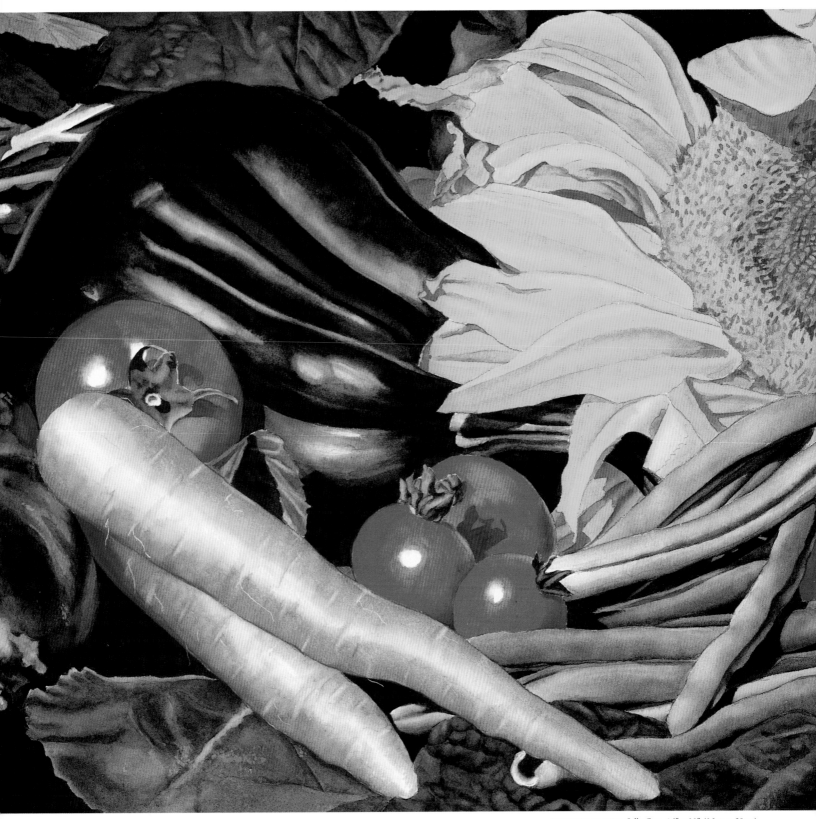

SATURDAY MARKET Sally Cays, 14" x 23" (36cm x 58cm)

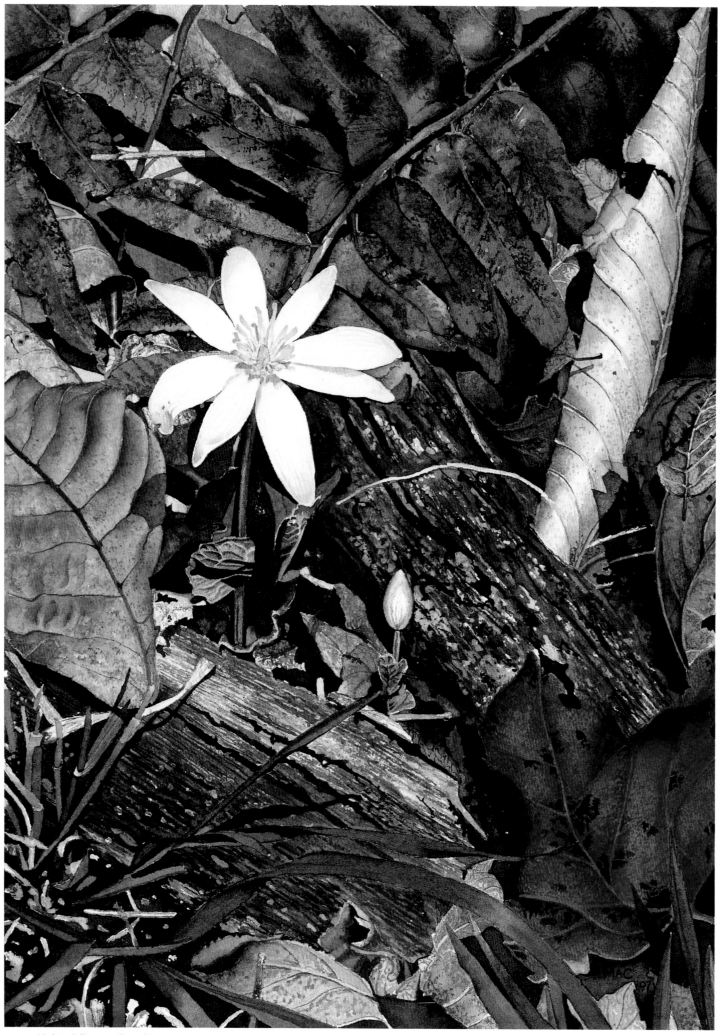

LEGACY Mark A. Collins, 10.25" x 7.5" (26cm x 19cm)

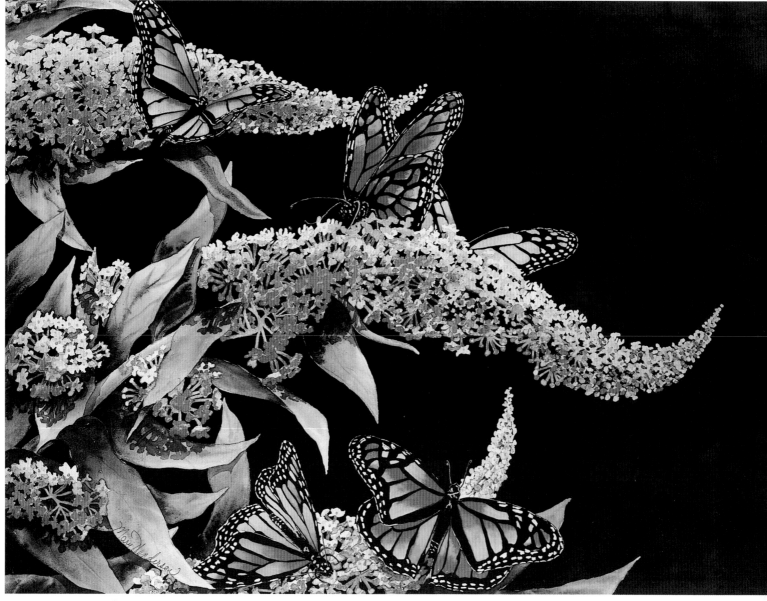

MANY MONARCHS Mary Henderson, 22" x 30" (56cm x 76cm)

⚡ Contrast Porous Flora With Velvety Fauna

MARY HENDERSON

I arranged this design from photographs taken at the butterfly gardens at Biltmore Estates in Asheville, North Carolina. Painting the Lochinch butterfly bush to appear fully round and porous was essential in order to contrast it with the velvety, delicate texture of the monarch butterflies. I then created the slightly mottled dark background, far behind all else, to make the butterflies come to life.

⚡ Make Texture Tell the Story

MARK A. COLLINS

The variety of textures on the forest floor in the springtime spells pure delight for the realistic watercolorist. In *Legacy* every phase of the life cycle is represented—from the fresh greens of the ferns and the satin ribbons of grass to the damp earthiness of decaying wood and the fragile crispness of fallen leaves. Texture tells the story. ⚡ A critical aspect of this painting was preserving the whiteness of the flower in such a way that gave it purity and form without creating negative space or the appearance of a hole in the composition. Cobalt Blue and Rose Madder Genuine—both purely transparent colors—made this possible, and contributed to the delicacy of the petals. The remainder of the painting was carefully executed around the flower in small sections of wet-into-wet washes.

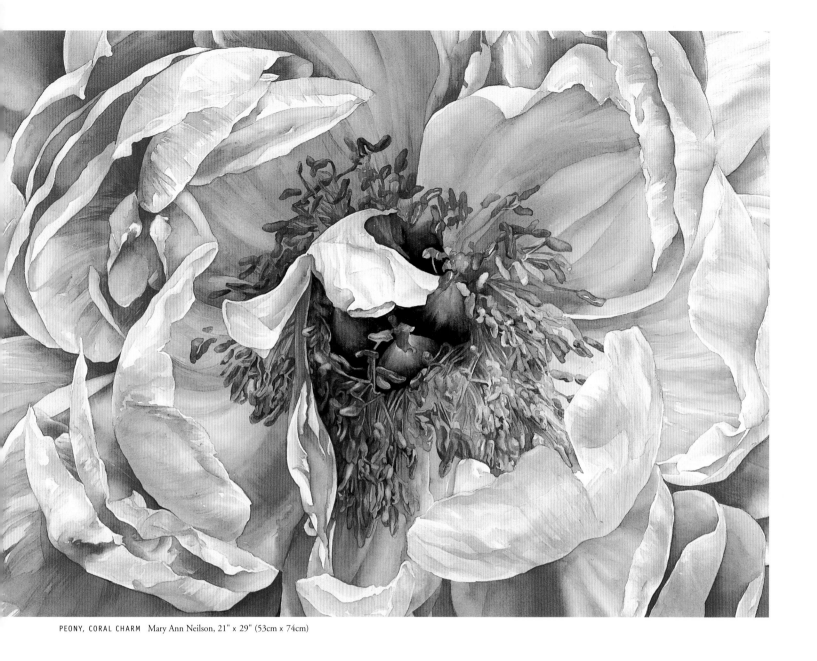

PEONY, CORAL CHARM Mary Ann Neilson, 21" x 29" (53cm x 74cm)

Painting the Texture of Fragility

MARY ANN NEILSON

This painting presented the dual challenge of describing fragile texture in soft light and exploiting the nuances of color within an essentially monochromatic image. ⚜ I began by painting and distinguishing the complementary colors of the shadows and the areas of reflected light. This is risky as they can become gray, but this risk creates a "road map" allowing me to freely paint the local colors in a wet wash. I used a limited palette of five transparent, staining pigments on 300-lb. (638gsm) Arches cold-press paper. To highlight the delicate texture of the petals and not that of the paint or paper, I avoided surface distractions such as sedimentary pigments, scrubbing and paint additives. There is a fine line between realism and a depiction of each petal vein. Too much accuracy and the flowers feel untouchable, as in old scientific botanical illustrations.

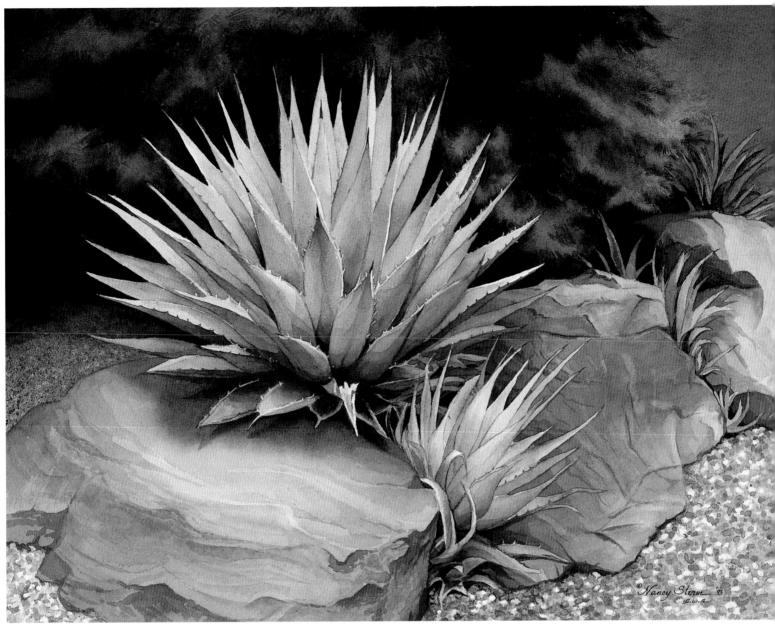

CACTUS II Nancy R. Stirm, 13" x 19" (33cm x 48cm)

Tapestry of Textures on a Colorful Gray Day

NANCY R. STIRM

Having always dreamed of seeing the desert in all its glory at sunrise and sunset, I was utterly dismayed to find myself immersed in winter storms and gray skies for my entire first trip to the Sedona in Arizona. Much to my delight, however, I discovered that the lack of sun seemed to intensify the beautiful variety of textures on the desert floor. The cool color scheme gave it a delicate feel in spite of the durability of the tenacious cactus and windswept rocks. ✍ Masking fluid was used to delineate the sharp points of the plant while laying in the dark background. Although I've never used white paint before, I found it necessary to add a touch of designer's gouache to my pigment in order to draw the tiny needles of the pine tree. I used a neutral wash for the ground before painting the small rocks individually. Some edges were softened with a cotton swab. I love details and rarely use a brush larger than a no. 7.

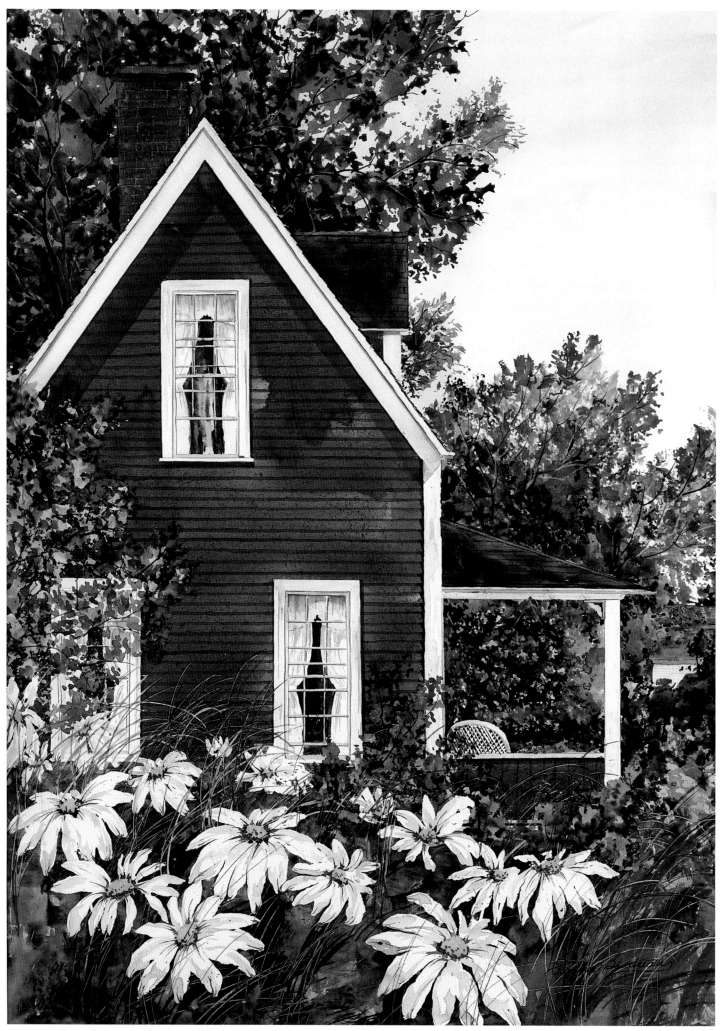

UN INSTANT D'ÉTERNITÉ Pauline Boudreau, 23" x 15" (58cm x 38cm)

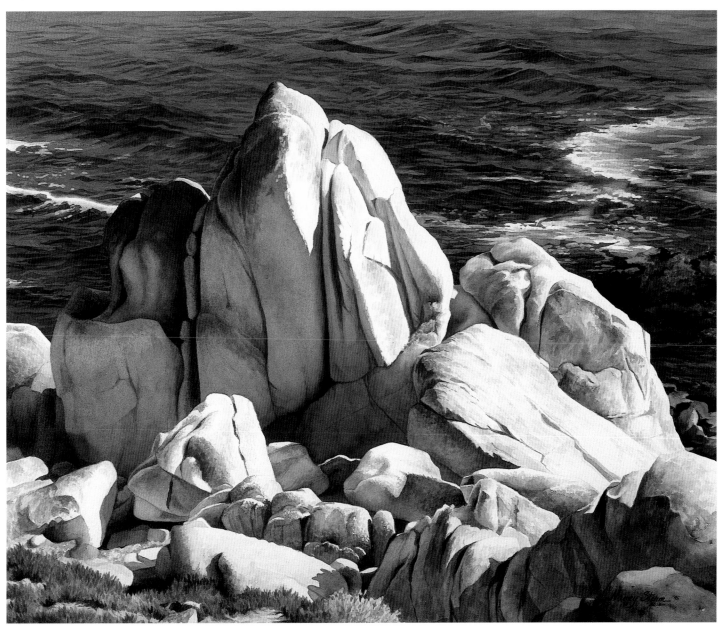

ROCK SOLID Nancy R. Stirm, 20" x 24" (51cm x 61cm)

♦ Layering Washes Develops Dimension and Depth

NANCY R. STIRM

This group of boulders on the rugged coast of California was like a huge sculpture, hewn by the ocean and the relentless elements of time. I begin all my paintings with a full-scale freehand rendering in order to work out my values and composition as well as potential painting problems. On this particular drawing I realized that most of the texture of the rocks was in the shadowed areas. I concentrated on giving them dimension and depth by incorporating some drybrush, small strokes of color and occasional spattering with a toothbrush. Each of these steps was allowed to dry completely before I added layers of thin washes, sometimes as many as twenty or thirty, to achieve the proper values. ✒ My palette is normally limited to a warm and cool version of the three primaries in addition to any other color I find necessary. Prussian Blue was used in painting the water.

◆ Light Enriches the Character of a Place

PAULINE BOUDREAU

My objective when I paint is to bring out color contrasts; I love to play with light! I love nature in its purest form, so I usually work on location in order to capture the essence and character of a place and to catch the light of the moment. ✒ This work was painted on three-ply bristol vellum. I love to paint on such a surface not only because it challenges me with a certain harshness, but mostly because it keeps color sparkling and deep. I used masking fluid to preserve the whites.

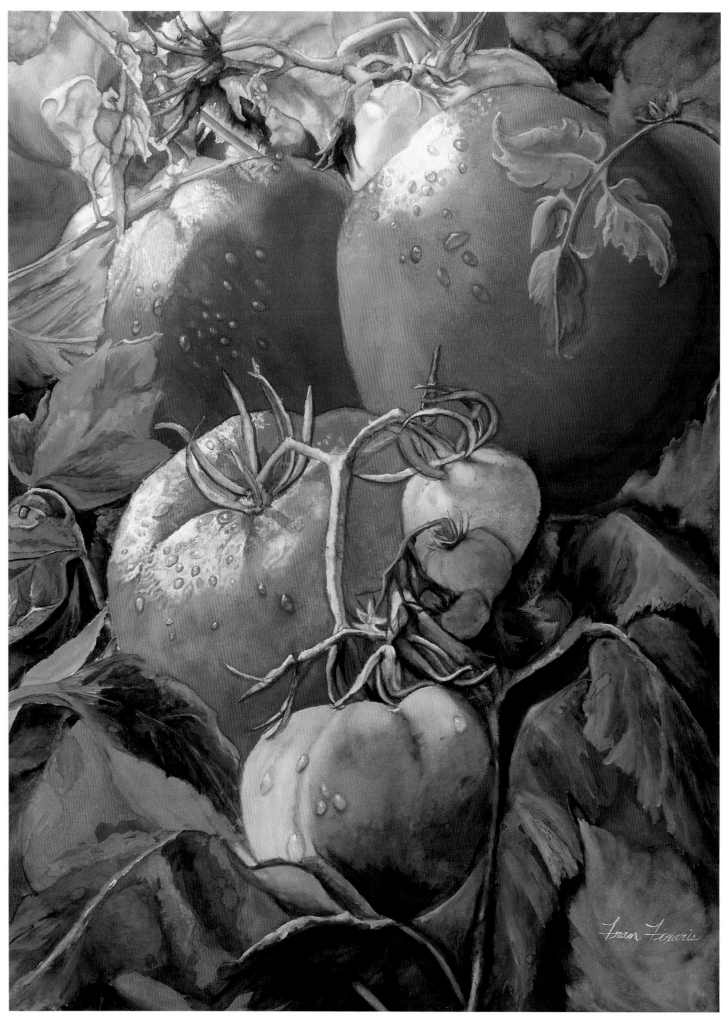

VINE RIPE II Fran Fixaris, 30" x 22" (76cm x 56cm)

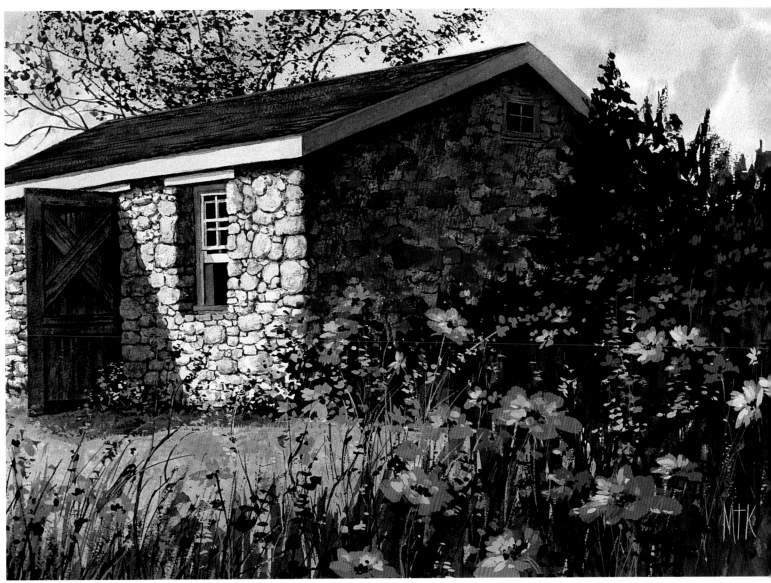

STONES AND POPPIES Mary T. Kingston, gesso mixed with watercolor, 12" x 16" (31cm x 41cm)

⚱ A Balance Between Rigid and Relaxed Textures

MARY T. KINGSTON

The tight rendering of the stones in *Stones and Poppies* calls for a relief somewhere in the composition. Thus, I chose for the foreground a loose, bright subject rather than another textured surface. ✒ Upon introducing the poppies as an afterthought, I realized it was essential to go back over the stones and subtly scumble the same pink tone, creating harmony throughout.

⟵ Contrast Complements in Both Color and Texture

FRAN FIXARIS

I have tried to capture the beauty and luscious quality of tomatoes in various stages, as they grow and ripen in the sun—to contrast the smooth, firm texture and shine of the red tomatoes against the rough, almost furry texture of the green leaves and stems. ✒ To create the various shadings and forms of the tomatoes, I laid in a wash, wet on wet, of the lightest color and let it dry completely. Then I added glaze upon glaze of deepening color, wiping (before dry) each one back with a wet paper towel, but leaving the darker shade around the edges to define shape. I did not mask out the whites because I wanted a soft edge to lead gradually from one color to the next. The mature leaves were done in direct textural contrast by using thick, near-opaque strokes of mixed greens. The tender leaves were painted wet-on-wet with a very thin glaze and blotted to keep highlights and transparency.

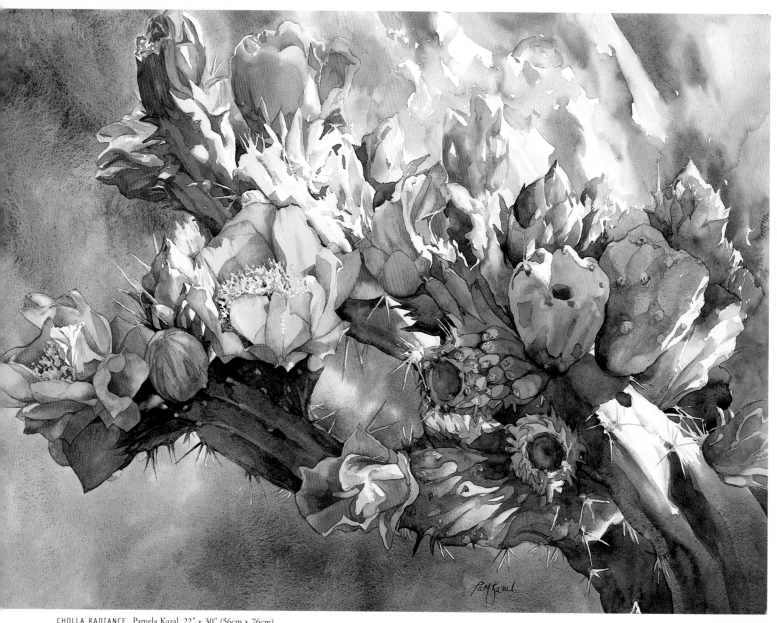

CHOLLA RADIANCE Pamela Kazal, 22" x 30" (56cm x 76cm)

⚡ Natural Textures Complement Pigment Textures

PAMELA KAZAL

This cholla in bloom lent itself perfectly to a theme on texture. Not only did the light create wonderful patterns and textures within the plant, but it also enabled me to play with two different kinds of texture in the background. I used loose, watery diffused color and wonderful sun-filled granulated passages, wet on wet, to contrast with the smoother stems and blossoms of the plant. ✍ I paint with a full spectrum of color on my palette, starting with the most transparent colors and finishing with the more staining and opaque. The granulated background, which I painted first, was made by wetting the entire area, painting in saturated colors, then tilting the board to help mix the paints. Cobalt Blue, Ultramarine and Cerulean in the mixes produced granulation.

➻ Nature's Natural Jewels

CONCETTA C. SCOTT

It was a cloudless autumn morning in early October. I was perusing the wares of a local farmer's market when my eyes fell upon a riot of color—Indian corn. Their kernels blazed like the beads of an Indian princess's necklace, topped off with a profusion of dried husks that twisted and burst out in all directions in their own symphony of self-expression. Gathering several bunches, I took them home and studied them, allowing the textures to drive me. My imagination suggested a farm, and the weathered door they hung against, replete with nail holes, rust and worn paint. The corn rises to the level of icon; it is a symbol of the autumnal harvest and its integral connection with all living things. ✍ I use 300-lb. (638gsm) Waterford or Lanaquarelle paper and transparent watercolors for multiple glazes. Drybrush and spatter add texture.

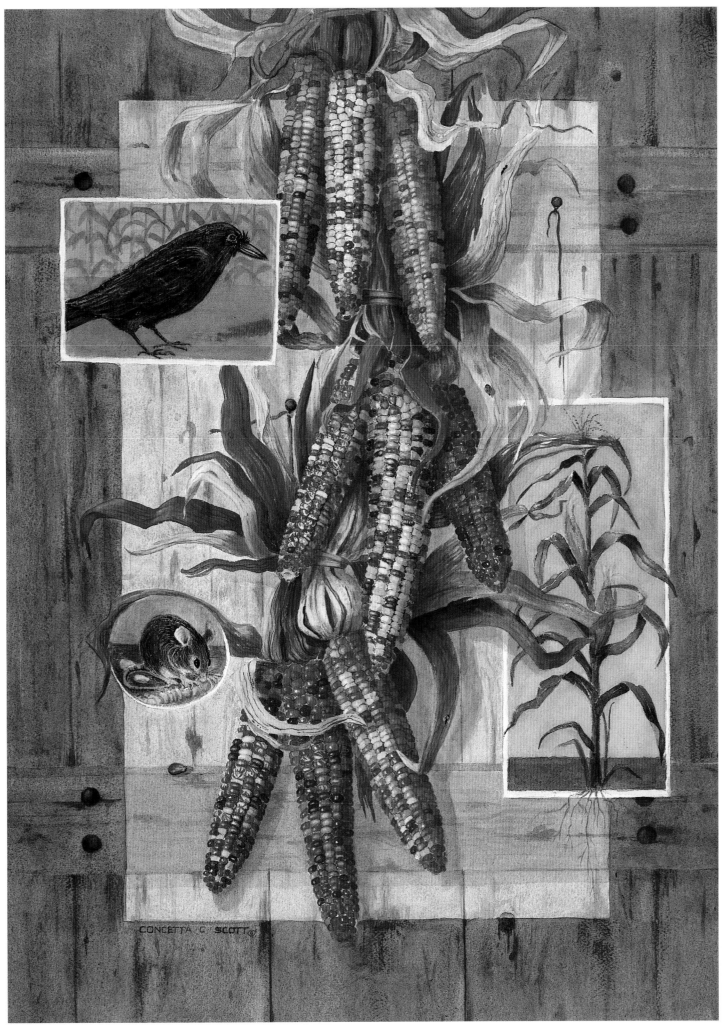

INDIAN CORN—LIFE CYCLES V Concetta C. Scott, 28" x 21" (71cm x 53cm)

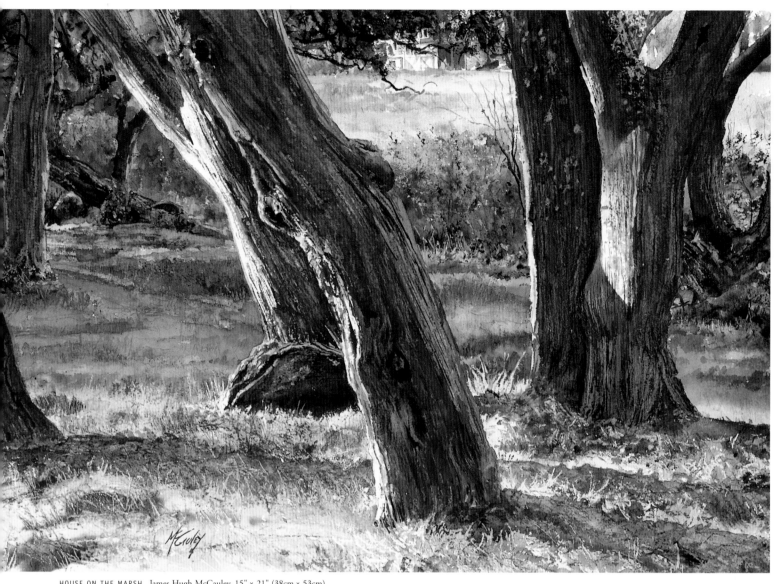

HOUSE ON THE MARSH James Hugh McCauley, 15" x 21" (38cm x 53cm)

Try 300-lb. Paper for Tree Texture

JAMES HUGH McCAULEY

The marshes on St. Simons Island in Georgia reflect the afternoon sun back into shaded areas, softening the scenery and evoking the sense of an English countryside. Textures are delineated and show the softness of the grasses in contrast with the gnarled hardwood trees. Arches 300-lb. (638gsm) rough paper allows me to float paint into areas without excessive buckling, and it permits hard treatment of the surface. I "draw" my tree textures with a palette knife on wet paper, floating several glazes into this damaged area. This forces the scraped lines to naturally form darker ridges. These "forced" happy accidents create the tree texture. Some fine brushstrokes complete the effect.

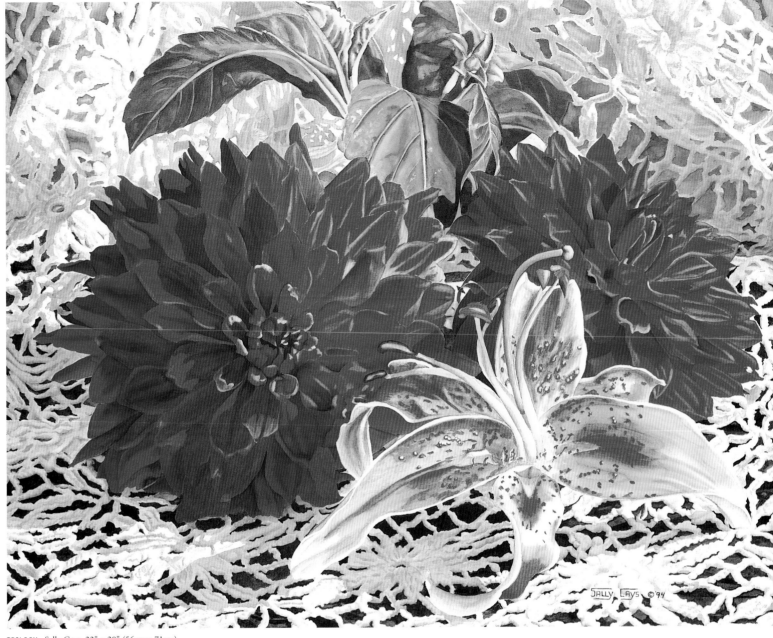

TRILOGY Sally Cays, 22" x 28" (56cm x 71cm)

Shadow Detail Creates Texture

SALLY CAYS

I have read that to paint lace, you simply paint the holes and the lace appears. In this painting, however, the lace was a tablecloth crocheted by my grandmother, and painting only the holes made it look like a flat paper doily. In order to create the true texture of the tablecloth, it was necessary to paint the shadows defining the feel of the yarn. ⁓ I began by painting the holes in the lace. This gave me a feel for the structure of the painting, and partially defined the shapes of the three flowers. After completing the dahlias and the stargazer lily using the techniques of glazing and lifting, I turned my attention once more to the lace, carefully painting the texture-defining shadows of its intricately crocheted pattern.

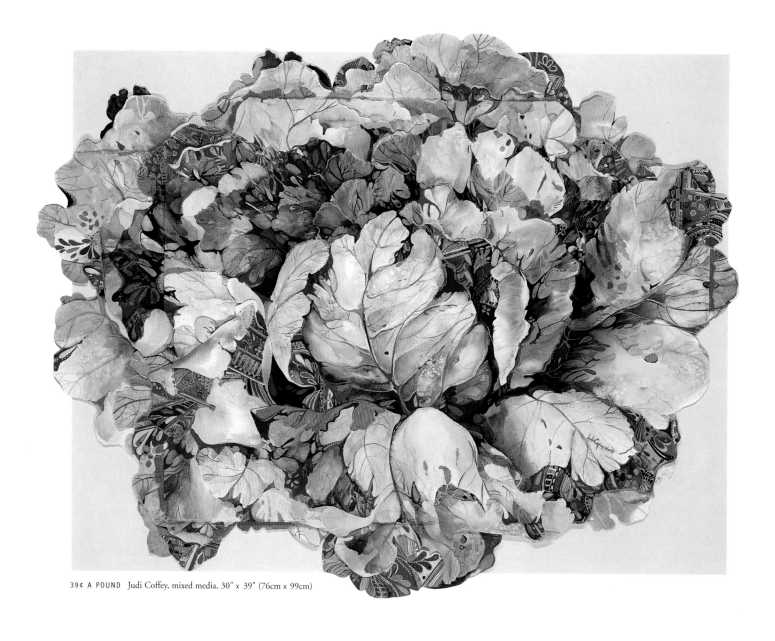

39¢ A POUND Judi Coffey, mixed media, 30" x 39" (76cm x 99cm)

♦ Mix Mediums for Exciting Surface Enrichment

JUDI COFFEY

Collage is the perfect medium for painting a leafy green cabbage. Some of the textures were created with multiple layered patterns on patterns. A more three-dimensional effect for the leaves was created with cut-out layers of paper. No drawing was done and so the cabbage just grew and grew, right off of the sheet of watercolor paper. ◦ꜱ This painting started out as a study in greens using transparent watercolor. This soon became very boring, and I began adding overlays of very diluted yellow and Thalo Blue acrylic paint. Even this wasn't adding enough excitement, so I scribbled Prismacolor pencils buffed out with Turpenoid. The patterned areas were carefully repainted and re-created with cut-out stamps I made while doodling on my erasers with an X-Acto knife. The final jewels of color were painted with opaque gouache and fiery radiant red and orange Cel-Vinyl acrylic.

↤ Repeat Colors to Unify Varied Shapes and Textures

NANCY ANN FAZZONE-VOSS

The fruit was an afternoon snack and the still life objects were just stacked together on a table, leftovers from another still life I had just set up to photograph. They were next to my camera and when I reached for the camera this accidental still life caught my attention. I noticed the colors first. The vibrant and busy colors in the foreground and background dramatically contrasted with the simple white flowers and repetitive oval shapes of the grapes. The wide variety of textures keeps the viewer's interest and leads the eye through the composition. ◦ꜱ To unify the many shapes and textures, I repeated some of the same colors in several of the objects. These included Quinacridone Magenta, Quinacridone Rose, Carbazole Violet and Payne's Gray.

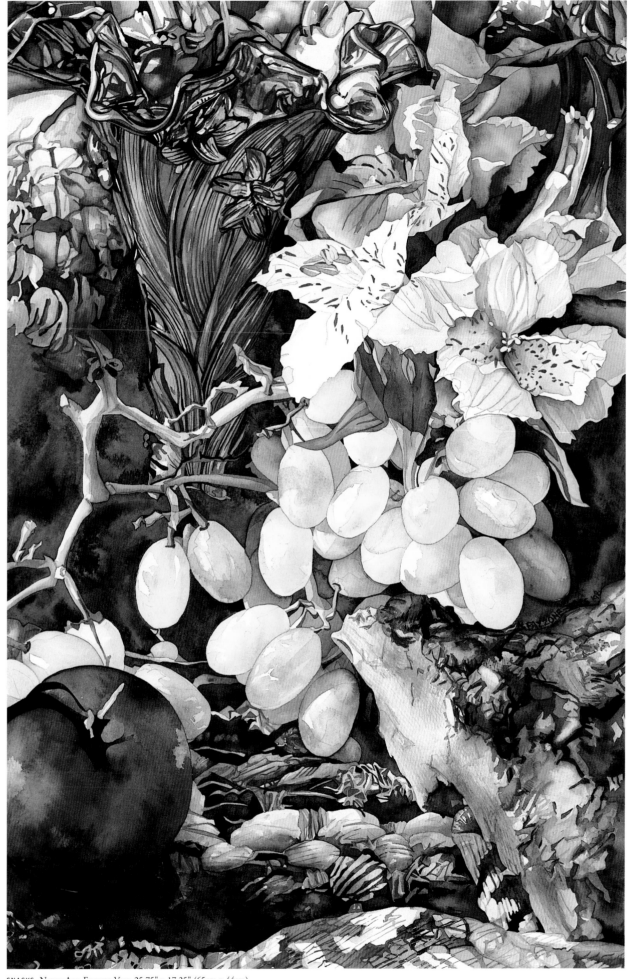

SNACKS Nancy Ann Fazzone-Voss, 25.75" x 17.25" (65cm x 44cm)

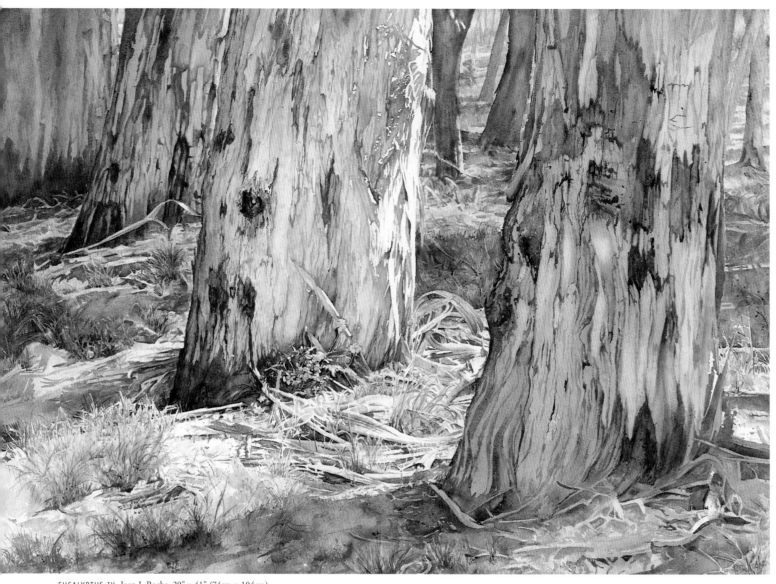

EUCALYPTUS IV Joan I. Roche, 29" x 41" (74cm x 104cm)

The Texture of Light and Shadow

JOAN I. ROCHE

The eucalyptus tree is fascinating with its ever-peeling bark and colorful surface. In the woods the sunlight casts soft shadows as it filters through the leaves, creating a magical effect on the tree surface and surroundings. I tried to communicate this feeling of tranquility. ∿ I used 555-lb. (1,174gsm) Arches cold-press paper because the paper texture works well with special techniques, such as salt sprinkled on barely wet paper and a spritz of water here and there to create the look of bark or sparkle of sunlight. I used some masking fluid to leave white for the sun-dappled effect and a glazing technique to build from light to dark. Only transparent watercolors were used.

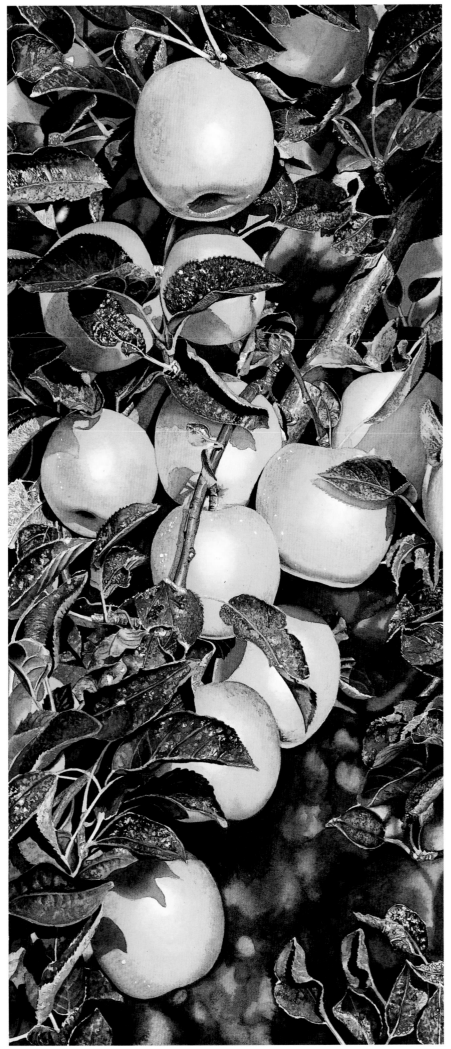

Let the Sun Illuminate Contrasting Textures

MARK A. COLLINS

On a spectacular autumn morning, the golden reflections of the sun on these apples brightened the entire day. Painting the glossy surface of the apples in contrast to the almost abrasive appearance of the leaves presented the initial challenge. The branches posed a further one: how to create texture that would suggest sufficient strength to support such a heavy load. ⁓ For uniformity in color and texture, the apples were developed simultaneously beginning with a halo of pure water surrounding the highlight. After enough time for modest absorption, a diluted mixture of Transparent Yellow was applied to the outer edges of the halo, blending smoothly into the white paper. Both warm and cool yellows, already mixed on the palette, quickly followed to create a smooth wash that defined the apple. This process, beginning again with a halo, was repeated more than twenty-five times, allowing each layer to dry completely. On some layers, Rose Madder Genuine and Quinacridone Gold were randomly dropped into the wash for variation in color.

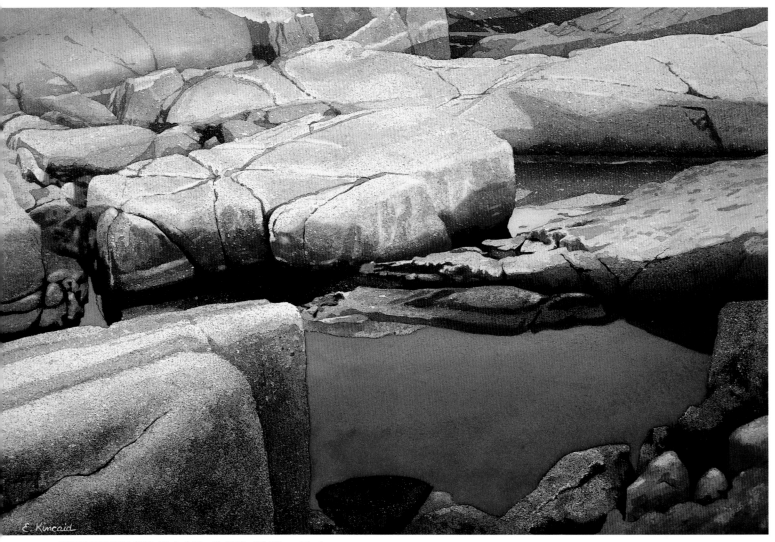

SUNSET AT PEGGY'S COVE Elizabeth Kincaid, 14.5" x 22" (37cm x 56cm)

✾ Layers of Spatter for Granite Texture

ELIZABETH KINCAID

I turned my back on the oft-painted lighthouse and village of Peggy's Cove. The turquoise jewel of water in sunstruck granite caught my eye. ✎ᕽ The rock texture was created using a toothbrush dipped in pure, diluted colors. With my thumb, I varied the direction or pattern of the spatter. After spattering, I blotted with a tissue for a subtle buildup of layers of tone and texture. For the larger texture of the foreground rock, I used dry-brush scumbling. Frisk Film and frisket masked the pool. I also spattered the rock with a frisket-loaded toothbrush to save some highlights. The pool was glazed with Aureolin Yellow onto wet paper and then with Thalo Blue. Permanent Rose and Thio and Winsor violets fill the painting's cracks and shadows.

✦ Combining Softer Natural and Manmade Textures

ELAINE HAHN

In contrast to the hard, reflective manmade surfaces brought out in *Reflections* (pages 12-13), the composition in *Starfish Bounty* utilized the softer natural and manmade textures and surfaces. The carpet, while soft and nonreflective on the surface, had a rigid pattern that, when viewed with the basket and shells, produced a very different challenge and composition. ✎ᕽ After drawing the basket, shells, urchin and starfish, I focused on the pattern in the rug and painted that first. After finishing the background completely, I worked on each natural element, bringing out the color, texture and shapes. The sand dollar remained as the white of the paper with only the detail pattern being filled in.

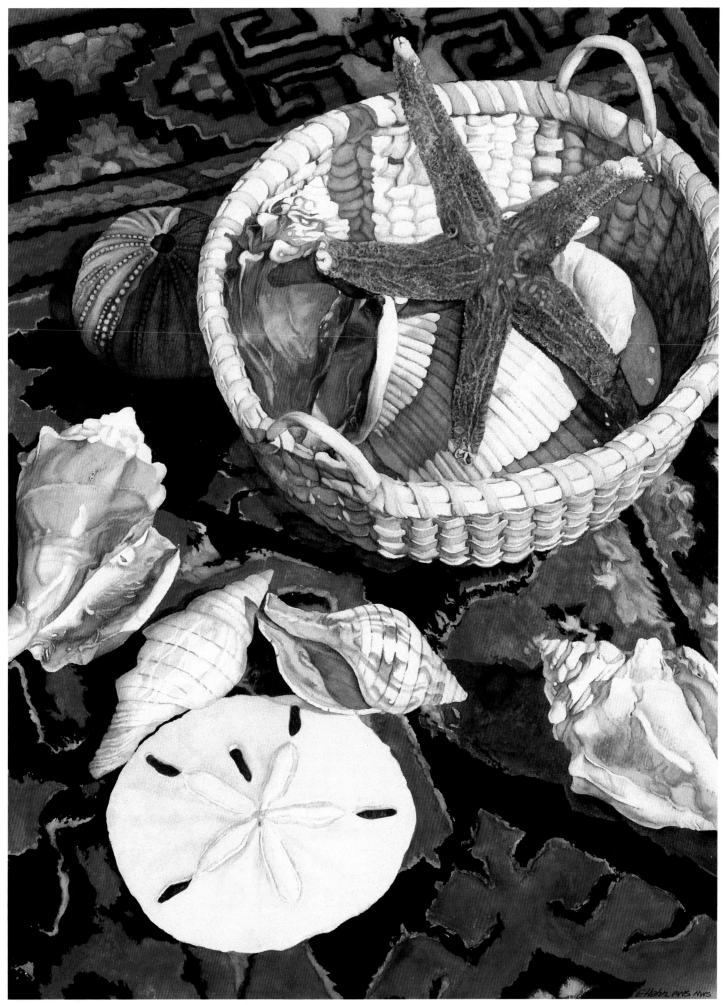

STARFISH BOUNTY Elaine Hahn, 30" x 22" (76cm x 56cm)

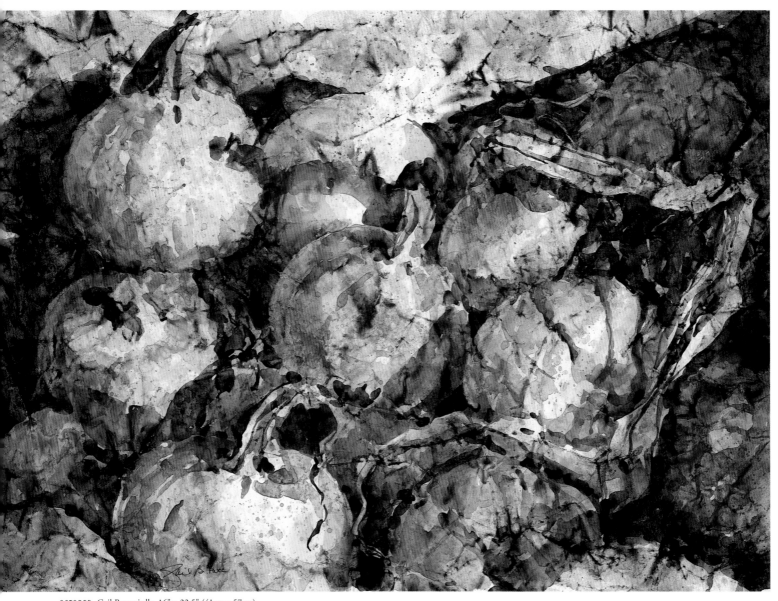

OCTOBER Gail Bracegirdle, 16" x 22.5" (41cm x 57cm)

⚲ Paint a Textural Subject on Crinkled Paper

GAIL BRACEGIRDLE

The large bin of pumpkins I spotted at a farm stand attracted my attention with its intense color and inter-esting repetition of shapes. The smooth round pumpkins, rough weathered wood and dried stalks presented a "natural" subject for the crinkled-paper technique I've been exploring. To emphasize the texture of the paper, I like to use watercolors that have a sedimentary or granular quality. Some of the main colors used were Raw Sienna, Burnt Sienna, Ultramarine Blue and Viridian. ⚲ I begin painting with a large brush on paper that has been thoroughly wet, then crinkled. The colors diffuse, flow together and settle into the folds. When the basic design of the composition is emerging and there are still distinct areas of color, I let it dry. Some areas are sprayed to keep soft edges when painting. I intensify colors with layers of rich watercolor glazes.

⟶ Take Advantage of Textural Contrasts

MARK A. COLLINS

For those of us in love with texture, the goal is to awaken in the viewer a tactile response—in this case, the desire to touch or grasp the fruit. The tough, almost leathery leaves with waxy surfaces and rough undersides became the perfect foil for the nearly polished look of the apples. ⚲ Liquid mask saved highlights on the apples, leaves and branches. This permitted carefree wet-into-wet painting on all surfaces. A multilayered foun-dation of Transparent Yellow on the apples both enhanced brilliance in color and allowed multiple seamless washes of various warm and cool reds. Smooth and absorbent 300-lb. (638gsm) hot-press paper made this possible. When the liquid mask was removed from the apples, various highlights were softened, many with pure water, others with diluted mixtures of Transparent Yellow or Rose Madder Genuine.

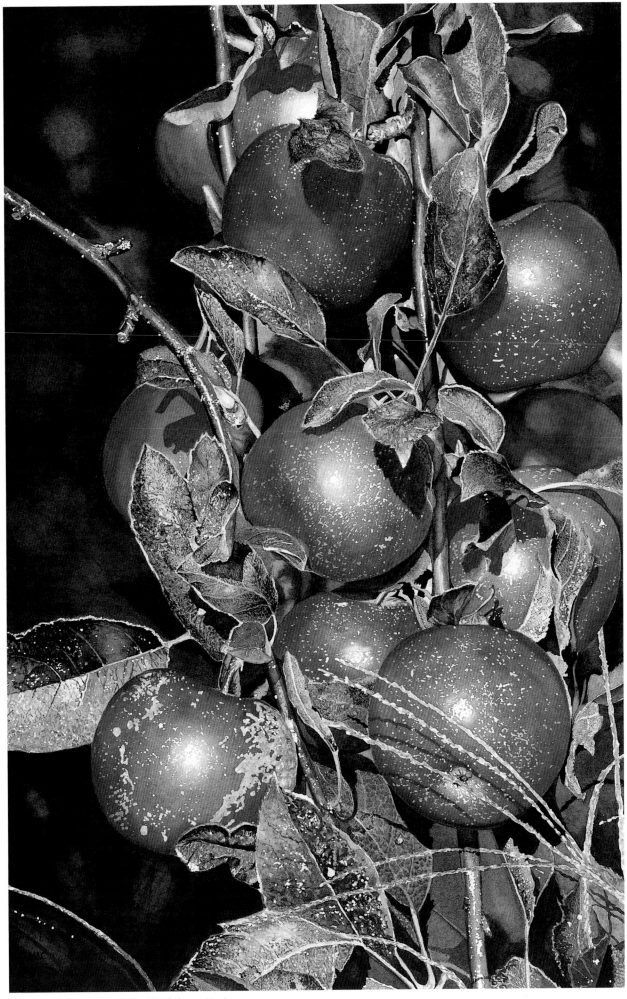

RED DOZEN Mark A. Collins, 18.75" x 12.25" (48cm x 31cm)

TIDE POOL Susan J. Connor, watercolor and acrylic, 22" x 30" (56cm x 76cm)

For *Tide Pool* I first thoroughly wet Arches 140-lb. (300gsm) rough paper and worked on an acrylic board to keep the paper wet longer and allow time for placing texture. I used ropes, jute, surgical gauze and silk threads to create an abstract design, initially working only with water. I then poured paint over the wet fibers. Different textures are created by baking the painting in the sun or freezing it on a cold winter night. After *Tide Pool* had baked in the sun all fibers were removed, leaving only textured pigments.

—*Susan J. Connor*

delighting in the
textures of color
and pigments

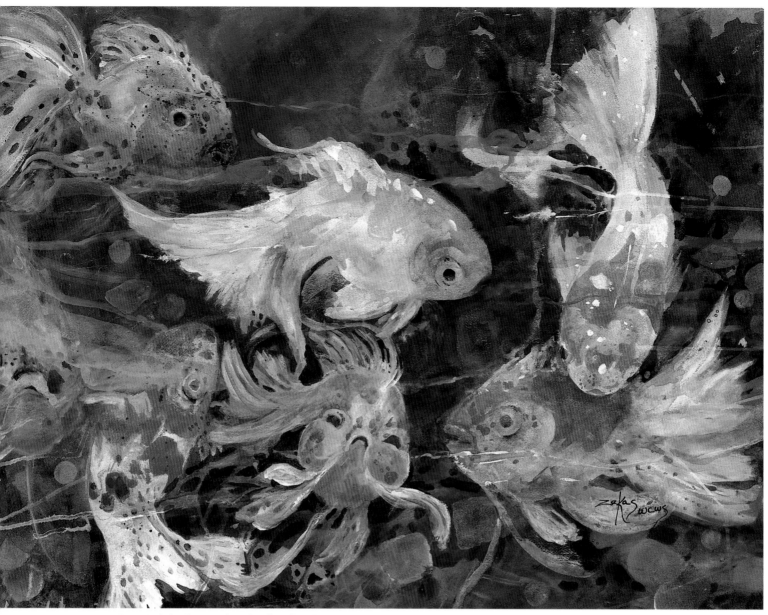

HELLO BLONDIE Connie "Zekas" Bailey, watercolor and acrylic, 22" x 30" (56cm x 76cm)

⚡ Mix Mediums to Explore the Limits

CONNIE "ZEKAS" BAILEY

Texture provides a way to increase and sustain the mystery of a painting. While I love the beauty of transparent watercolor, I find myself wanting ways to further expand and explore textures. To solve my dilemma I started mixing mediums of gouache, acrylics and inks with my watercolors. This allowed me the freedom of sponging out, scraping in and painting around shapes to make numerous adjustments. ❧ I have changed my thinking from only "transparent" to whatever medium will produce the best results or desired effects, and create a visual rhythm. By painting around shapes and layers of glazes, the hidden abstractions in the dark depths of the water are revealed; yet, the feel of the fish in the water has been captured.

⟶ Have Fun With Spontaneous Layers

DOLORES ANN ZIEGLER

Done in my usual spontaneous though slightly planned way, light rice papers and splashes of bronze acrylic paint gave this painting a look of holiday brightness and glitter... hence its title, *Holiday Windows*. ❧ Since the windows in the painting were the most important element, I concentrated on the application of rice papers to bring in light and drama. Flicking and splashing bronze paint added the holiday glitter. The dark contrast was made from layers of my favorite mixture of Payne's Gray alternated with blues and reds in acrylic. Rubber-gloved handprints are at the top of the painting while heavy white gesso finishes the bottom. All of it was painted with a 2-inch (5cm) brush and a rigger.

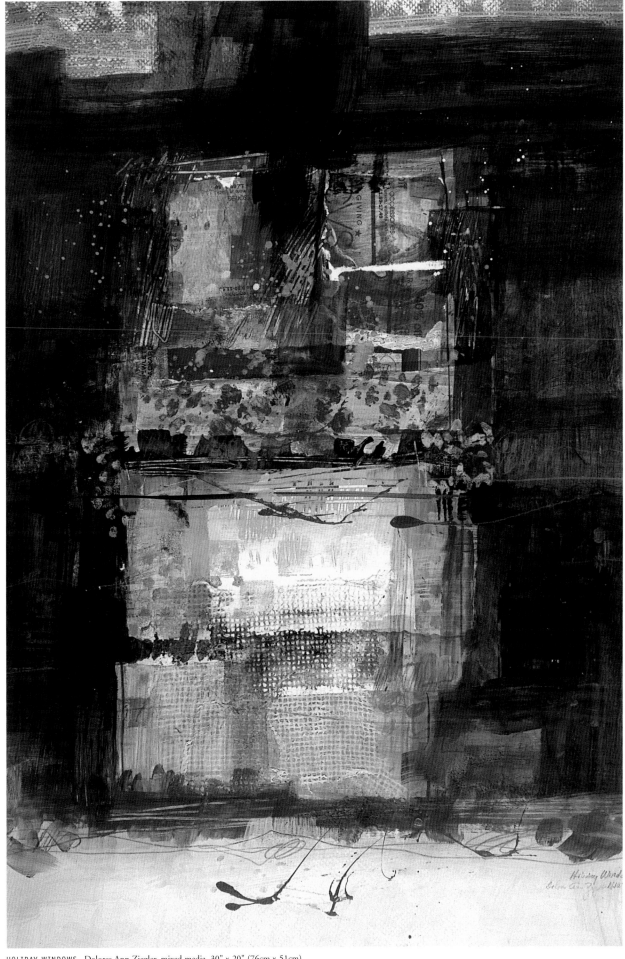

HOLIDAY WINDOWS Dolores Ann Ziegler, mixed media, 30" x 20" (76cm x 51cm)

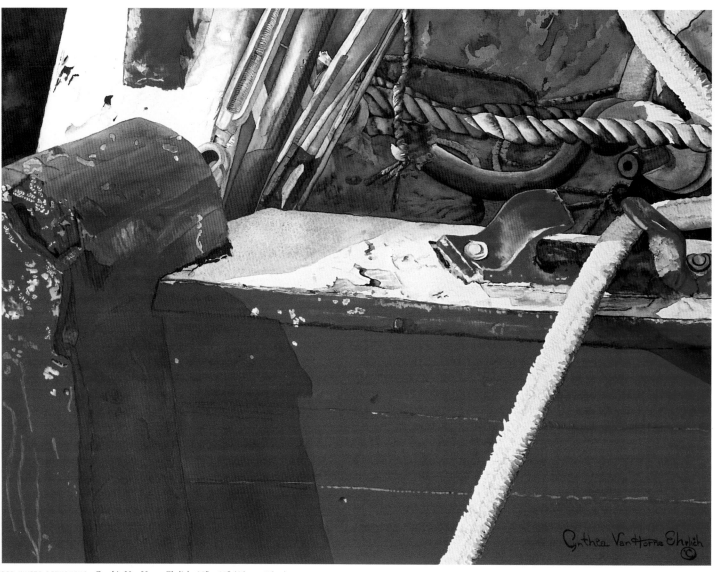

RED WHITE RETURNING Cynthia Van Horne Ehrlich, 22" x 30" (56cm x 76cm)

✦ Carefully Develop the Texture of a Dominant Color

CYNTHIA VAN HORNE EHRLICH

I was drawn in by the many textures on this boat in the fishing village and artist community of Provincetown, Massachusetts. This included intriguing rust, rough ropes, dents in the wood and the layers of paint revealed by recent chips. One can just imagine what stories this boat could tell. ◄ For me to successfully create texture, I must focus on value and color, and ignore the subject. In order to build a glowing red for the boat, I first applied a yellow glaze, then added successive glazes of Winsor Red and Alizarin Crimson. The blue sky reflections were then glazed on the red post and cleat. I glazed shadows of transparent Winsor Violet over the red, taking care not to disturb the easily liftable reds. The rust was created by playfully dropping in Winsor Violet, Cadmium Orange and Winsor Red, letting them mingle. The only liquid mask used was for some of the chipped paint.

➡ Use Rich Color as a Foil for Texture

DONNA JILL WITTY

I found about thirty of these battered old dories nestled alongside a working fishing dock. The red boat simply glowed in the sun. I was excited by the jewel-like colors as a foil for all of the clutter, rust, weathered wood and peeling paint. ◄ Careful and selective application of Maskoid helps to create the textural interest that is used to play against the rich darks and intense color of this painting. Two sets of complements and a charged mixture of Winsor Red and Cadmium Scarlet are used for color. Velvety darks in the shadows and water make everything "pop"! Direct painting of cracks, stains, wood grain, ropes, etc., adds the textural elements that make the boats "feel" real.

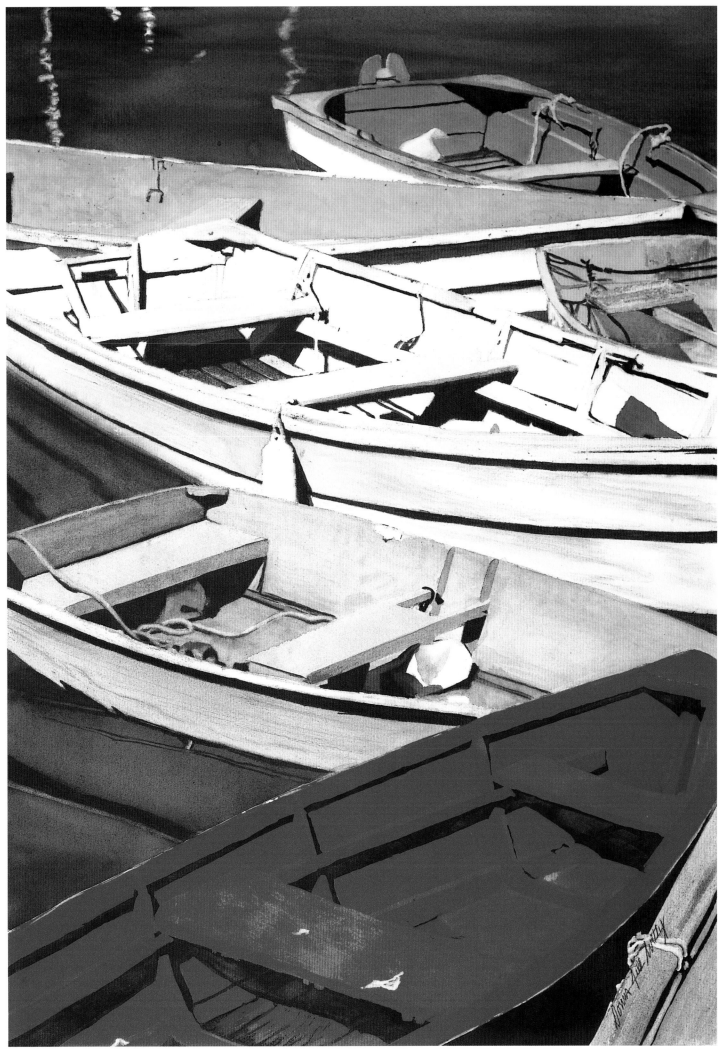

HARBOR GEMS Donna Jill Witty, 29" x 21" (74cm x 53cm)

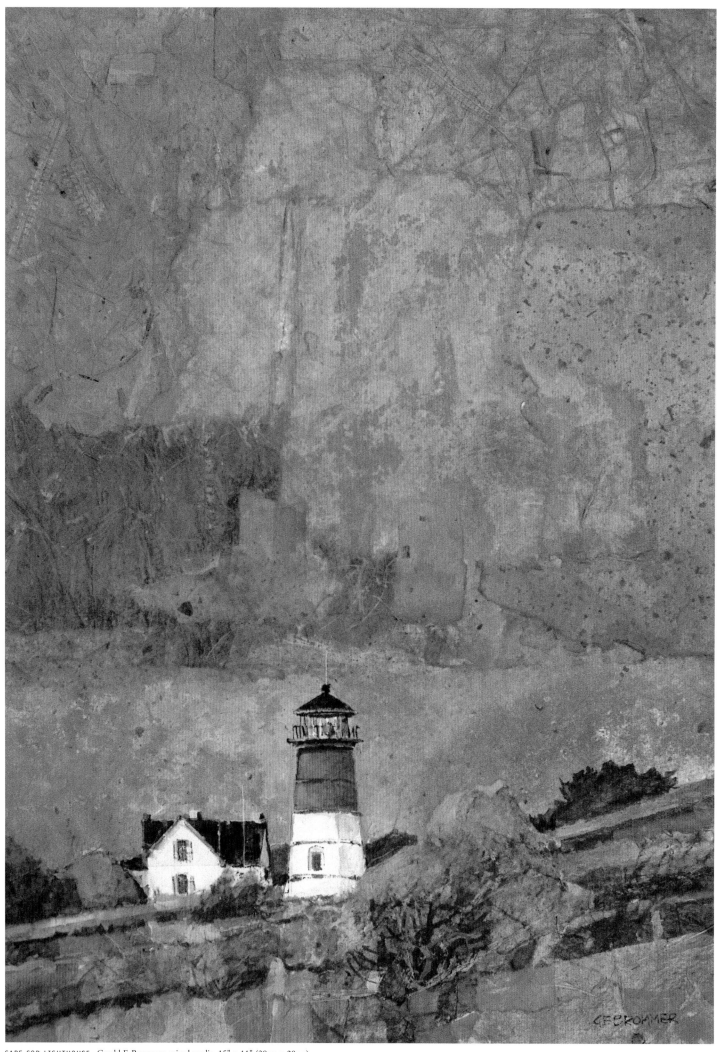

CAPE COD LIGHTHOUSE Gerald F. Brommer, mixed media, 15" x 11" (38cm x 28cm)

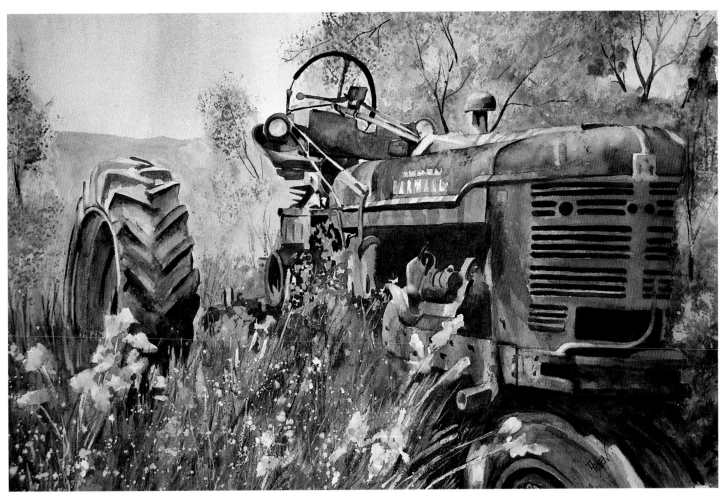

McKINSTRY TRACTOR Diane Allen, 20" x 26" (51cm x 66cm)

⚡ Play With Paint to Capture Textural Variety

DIANE ALLEN

While buying flowers at an old nearby farm—a serendipity of textures—I stumbled upon this old abandoned tractor. I've recently discovered the challenge and fun of manipulating watercolors to re-create a variety of textures. I like to capture my subjects at long-shadow hours. The sharp contrast between lights and darks emphasizes any roughness or raised material. I still enjoy playing with new techniques and new ways of manipulating paint. ⤳ Numerous textures can be created by the manipulation of paint and water: painting wet-on-wet, using a spray bottle and some salt, tilting the paper to let paint run, spattering, etc. I like to use a paper with a strong sizing and nonstaining paints because I pull off half as much paint as I put on. By using sedimentary colors such as Manganese Blue, Raw Sienna and Burnt Sienna, I am able to create other textural effects.

⤶ Try Rice Paper to Enhance Your Surface

GERALD F. BROMMER

This small collage painting began in my sketchbook, from a drawing of the lighthouse and its environment made several years ago. The medium of washi (rice papers of many textures) stained with watercolor was used to develop the image and create the textural surface, which is a vital aspect of much of my work. ⤳ The process for this technique begins with the staining of washi (perhaps fifteen varieties of rice papers) with both transparent watercolor and gouache. When dry, these textured colors are torn and collaged to the support with acrylic matte medium to create the basic roughed-in image. Adjustments and final details are added with both transparent and opaque colors, used thinly so the textures of the washi remain evident.

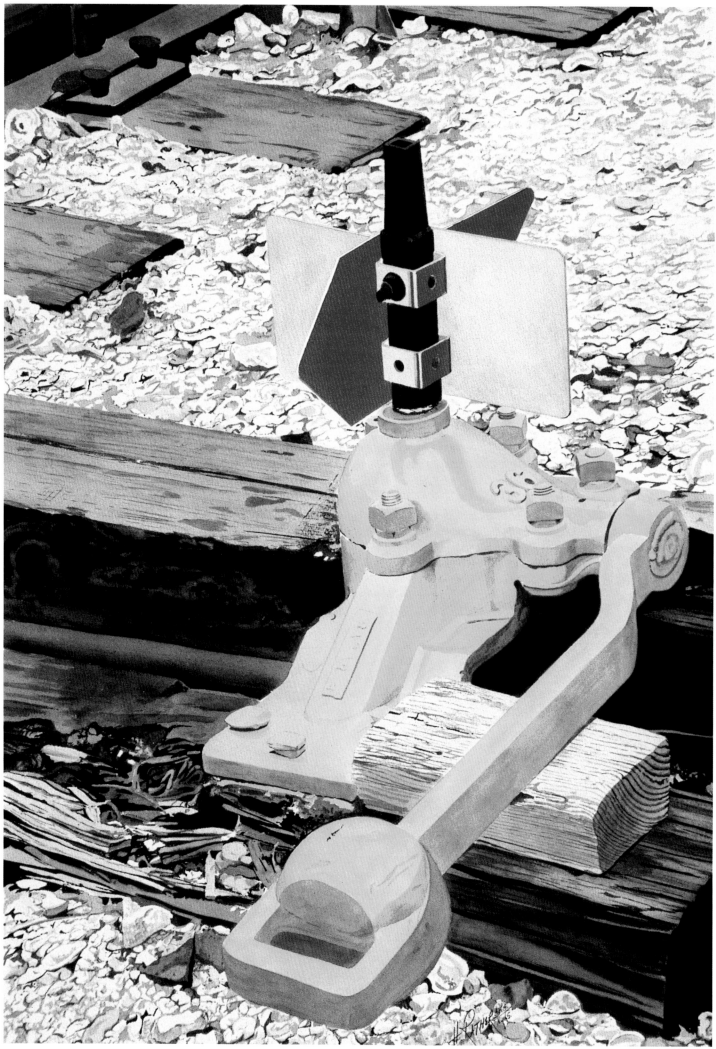

SWITCH Herb Rather, 30" x 22" (76cm x 56cm)

HEAVEN TO EARTH Karen Knutson, watercolor and collage, 21" x 29" (53cm x 74cm)

⚶ Anything Goes

KAREN KNUTSON

By adding collage to my watercolors, a whole new world was opened to me. Collage adds texture, brighter colors and depth to my paintings. "Anything goes" is the phrase I use when painting with collage. I use rice paper, tissue paper, string, metallic ribbons, wrapping paper and gauze, just to name a few. I am constantly looking for new materials to add different types of textures. ⇒ I begin my paintings on a wet surface with no particular image in mind. I place exciting colors next to each other and tip the paper to allow colors to flow into each other. After drying, I collage with rice paper, ribbons, etc., using acrylic matte medium as a glue. The next step involves glazing in order to "weave" the rice paper into the painting. Finally, I negative paint to create a pathway for the eye to follow. All this achieves a three-dimensional look with texture.

⇜ A Textured Monochromatic Background Sets Off a Bold, Colorful Subject

HERB RATHER

Several things attracted me to this subject, found at a dockside railway track. First, the switch itself is such a strong image in shape, color and texture. Beyond that, the oyster-shell ballast and the weathered iron and wood offered further challenges in depicting a variety of textures. For the shells, I carefully delineated a few of them in the foreground to establish identification. The remainder are suggested, with the viewer's imagination providing the details. ⇒ The center of interest is certainly the switch itself, with Indian Yellow, Winsor Red and black providing the contrast to the subdued, monochromatic surrounding area. Various combinations of Ivory Black, Thalo Blue and Sepia predominate in the wood, metal and shells, with a few touches of warm earth tones added for interest. The painting was completed on dry Arches rough paper.

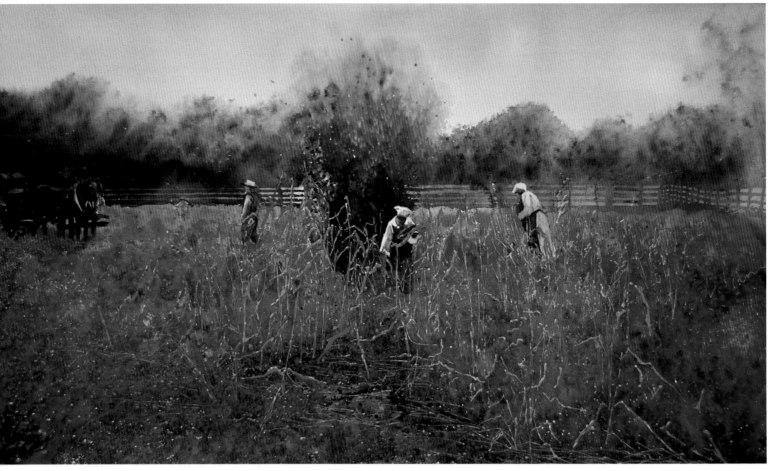

OLD WORLD WISCONSIN: HARVEST ON THE FARM Donna Jill Witty, 23" x 39" (58cm x 99cm)

⚱ Pigments Can Create Their Own Texture

DONNA JILL WITTY

This painting moves from the heavily textured foreground of the cornfield to the almost iridescent haziness of the background area. There is a unique feel to the days of late fall. The warmth of the sun, low on the horizon, tempers the bite in the air. The glaring light makes even the atmosphere alive with movement. When I came upon these reenactors at Yankee Village in Old World Wisconsin, I was transfixed. ✑ To build the texture in the foreground, I first masked a few key cornstalks and then began throwing paint—lots of it! I moved back and forth from Winsor Yellow to Aureolin to Cadmium Scarlet, Winsor Red and Brown Madder. As these pigments began to intermingle on the surface of the paper, they created their own distinctive texture. I used a palette knife to rough out the impression of more cornstalks and then spattered in additional paint. After removing the Maskoid, I painted back into the white areas and voilà, a cornfield!

↠ Make a Bumpy Surface With Matte Medium

BARBARA OLINE

My goal is to organize chaos into something meaningful and to have fun while doing it. Nothing is ever ruined—it is just in a state of transition, like life. ✑ I put matte medium on an old painting, let it dry and painted over it. I used the matte medium full strength, dabbing it with a sponge to get bumps and ridges. When the color was dry, I rubbed some of it off with alcohol to allow the color underneath to show through.

EVIDENCE OF TIME Barbara Oline, watercolor, gouache and acrylic, 18" x 13" (46cm x 33cm)

ASTORIA Ann Hardy, watercolor, acrylic, ink and watercolor pencil, 22" x 30" (56cm x 76cm)

Enjoy the Process of Creativity

ANN HARDY

I came from a family that gave unconditional, deeply committed love. And I desperately want to leave a legacy of love and beauty after me. To do that, I think you must love the process of both life and painting. The painting process begins with the image—usually an alliance with nature—manipulating paint, and rescuing (maybe). It's important to find the process (journey) joyous, because who knows when they've reached the destination (product). ✺ Most of my creative process takes place on the paper. I start with an abstract underpainting, and do a lot of spattering, scratching, scraping and blotting. Knowing what to leave and what to paint out is the judgment.

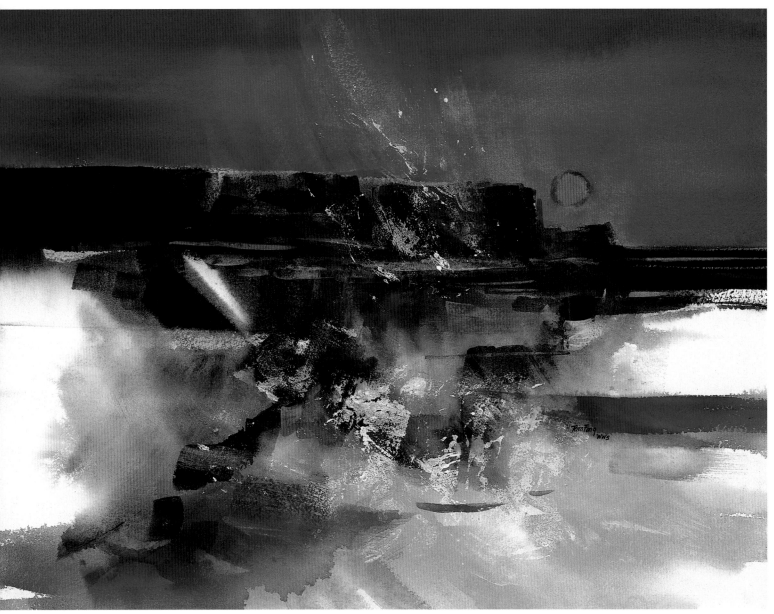

PACIFIC COAST SEASCAPE Tom Fong, watercolor and acrylic, 22" x 30" (56cm x 76cm)

☝ Express the Essence of a Seascape

TOM FONG

Pacific Coast Seascape was inspired by my travels along the Pacific Coast. I painted it by memory, working spontaneously, wet-into-wet, with bold strokes. I achieved the mood of the coastline with a strong horizontal pattern, and created tension by superimposing curvilinear and diagonal strokes to simulate the energy of the crashing white waves. ❧ I started the painting with transparent watercolors, and after drying, decided to intensify parts of the seascape by painting over some areas with acrylics. The texture of the waves was improvised by applying Winsor & Newton Iridescent White acrylic at random on a piece of newsprint, and then placing it paint-side down on the surface and applying hand pressure to spread the paint. I used brushwork and spattering to complete the painting, always keeping balance and harmony in mind.

↝ Render the Brilliant Hue of an Exotic Bird

DONNA FRANCIS

I studied many scarlet macaws in preparation for this painting. I visited pet shops and the zoo and took numerous photos. I also collected many colorful feathers. The striking colors of the large scarlet macaw present a wonderful range of brilliant hues. This native of Central America and South America defines the excitement of the area and inspired me to capture its dramatic essence on paper. ❧ After making a detailed sketch on tracing paper, I transferred the likeness to Arches 300-lb. (638gsm) hot-press paper. I used a vivid palette of predominately transparent primary colors.

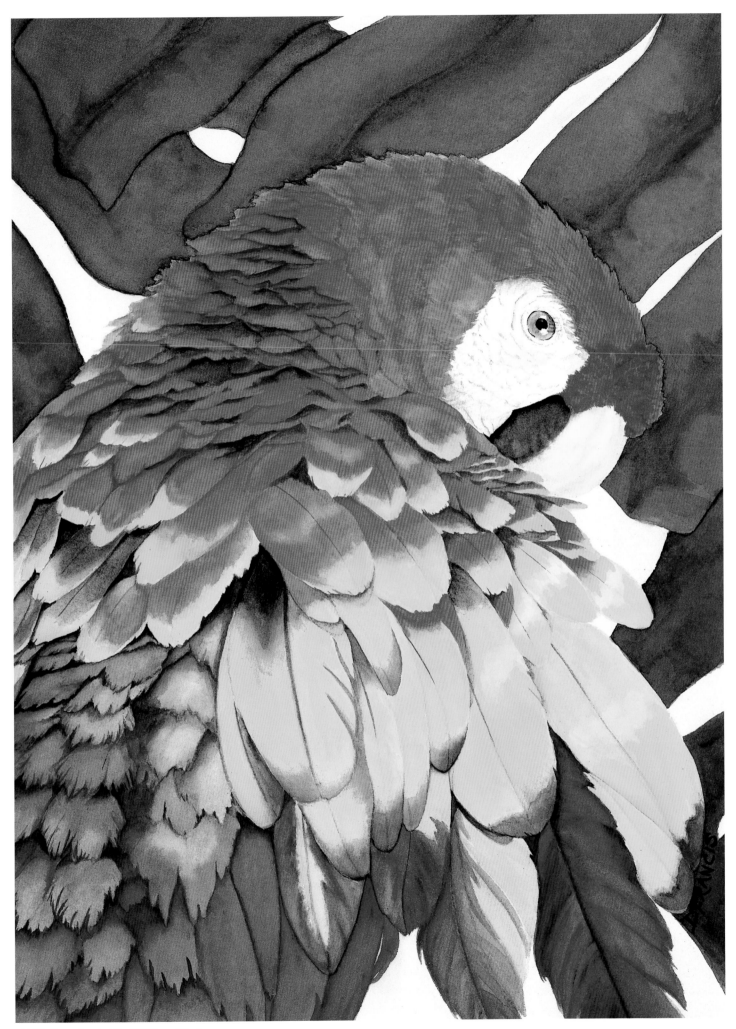

MACAW! Donna Francis, 15" x 11" (38cm x 28cm)

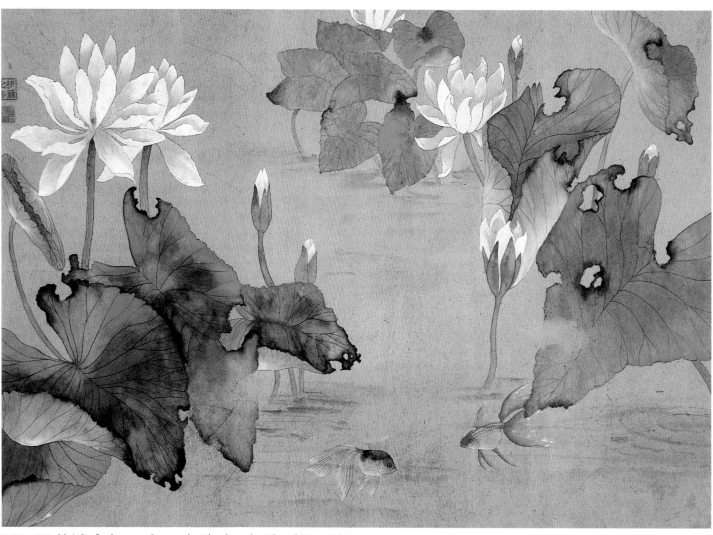

WHITE LOTUS Maria Josefina Lansangan S., watercolor, ink and gouache, 23" x 33" (58cm x 84cm)

Chinese Paper Imitates
the Effect of Antiquity

MARIA JOSEFINA LANSANGAN S.

I have always admired the splendor of antique oriental screens with their tranquil simplicity, poetry and vividness. This admiration inspired me to paint the lotus in the centuries-old traditional Chinese outline style. I wanted to capture the white lotus flower in its simplest delicate form to portray a sense of quiet inner peace to the viewer. ✍ I drew my completed sketch on a separate white board. With a fine wolf-hair brush I traced it with freshly ground ink on Shuan Chinese paper, which is very thin and nonabsorbent. To imitate the effect of antiquity, I crumpled some parts of the paper before I applied a layer of ink wash. After the first wash was bone dry, a very light wash of umber was next. All the colors used were made from minerals and plant extracts that come in solid form except for the Chinese White and green poster color. When finished, *White Lotus* looked like an antique painting.

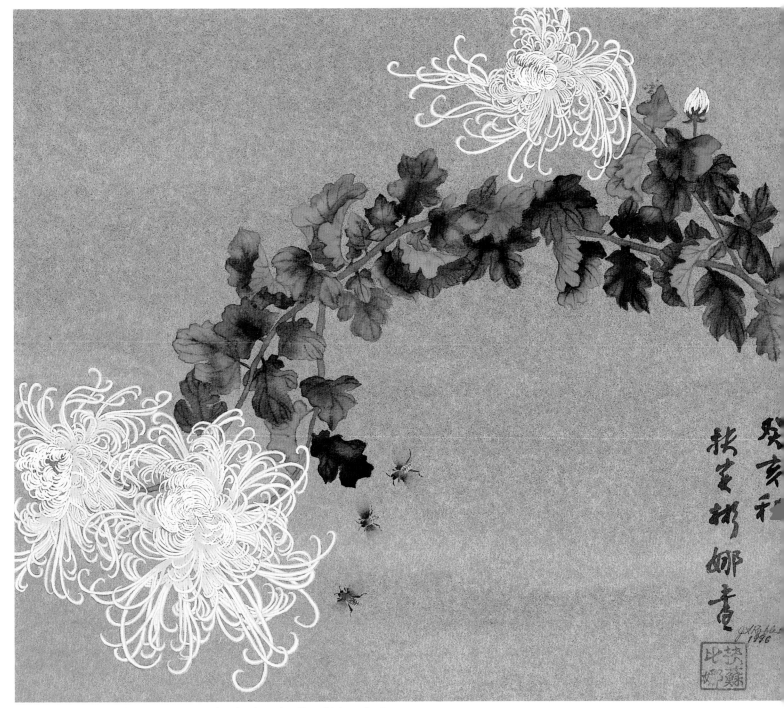

CHRYSANTHEMUM Maria Josefina Lansangan S., watercolor, ink and gouache, 14" x 17" (36cm x 43cm)

Gold-Specked Cotton Paper
Gives Whites Boldness

MARIA JOSEFINA LANSANGAN S.

Chrysanthemum blooms bring a welcome ray of brightness to a group of visiting bees and delight to the viewer. The cascading slender petals forming a gracious curve express the way I see this simple and unpretentious flower. ✺ In this composition, I used gold-specked cotton paper because it was the most striking way I could think of to make the whiteness of the flowers jump out of the painting. The juxtaposition of the smooth texture of the gold background and the pure-white opaque flowers gives the composition vitality and boldness, yet it is never tiring to the eyes.

As I look into the eyes of my subjects, I try to envision their life's experiences; I attempt to look beyond the physical features and get a glimpse of the soul. The comical gentleness in the eyes of this Haitian man drew me in. The wrinkled countenance is a masterpiece; each wrinkle has a story, and when woven together they create the richly textured tapestry of life. I use a technique in watercolor a lot like pointillism. I created the pores of the skin by using my Kolinsky no. 4 round brush on its tip. I began by dotting each pore with a light skin-tone color, and then I gradually worked my way darker until I reached the effect I desired, thus giving the skin a textured appearance.

—*Suzanna Reese Winton*

portraying the textures of
people
and animals

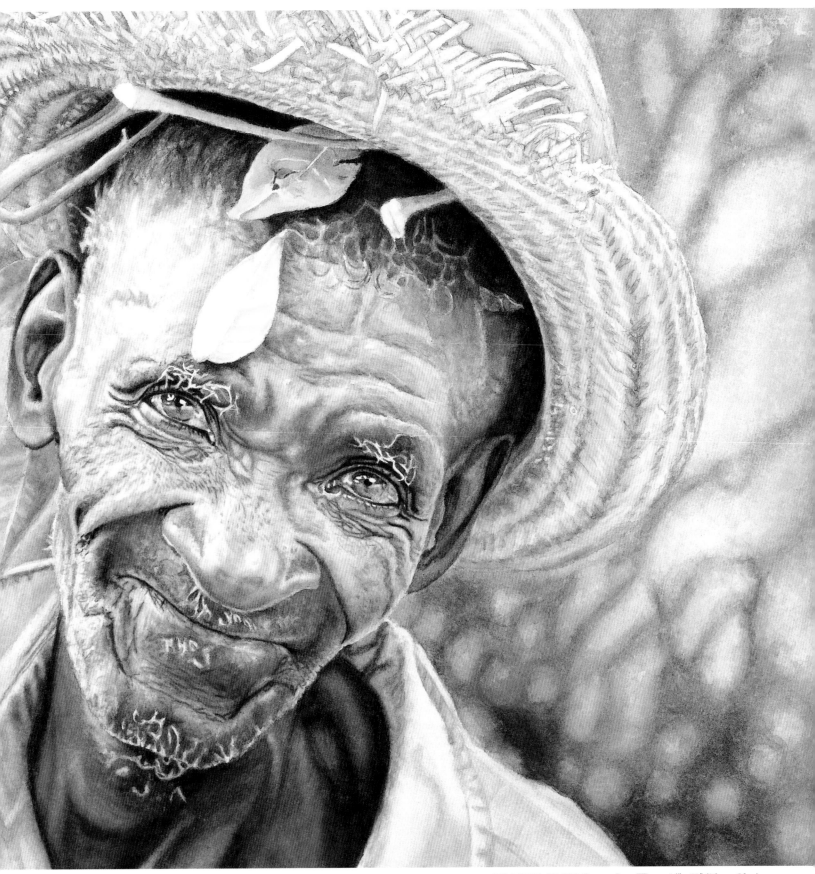

THE HAITIAN HAT MAN Suzanna Reese Winton, 14" x 22" (36cm x 56cm)

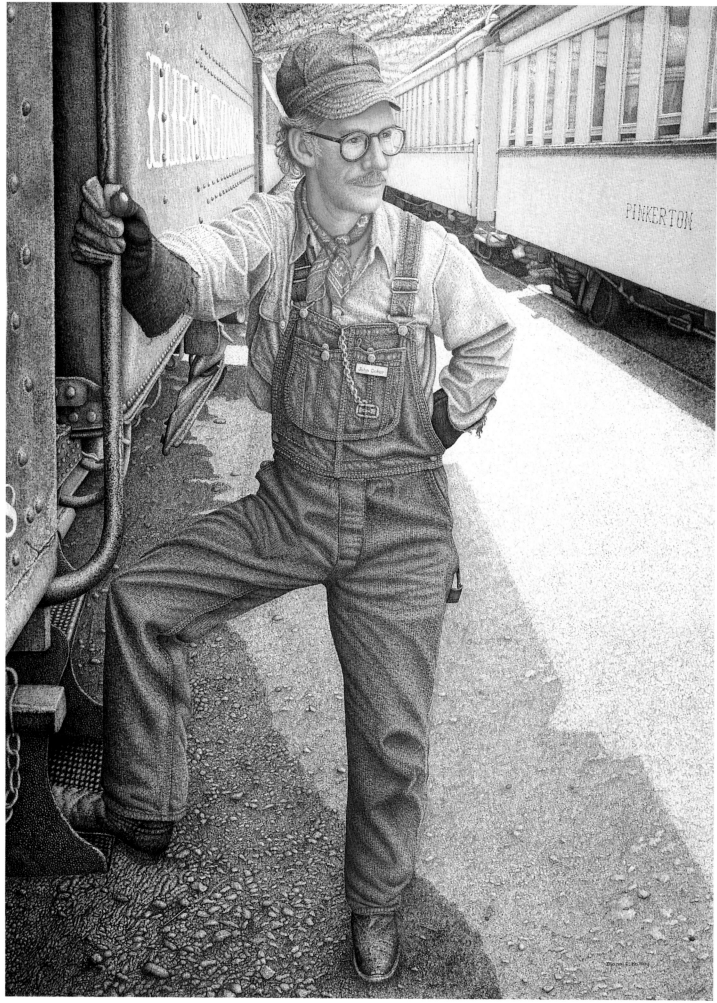

PORTRAIT OF JOHN COKER—DURANGO TO SILVERTON NARROW GAUGE Diane E. Halley, 28.75" x 21.75" (73cm x 55cm)

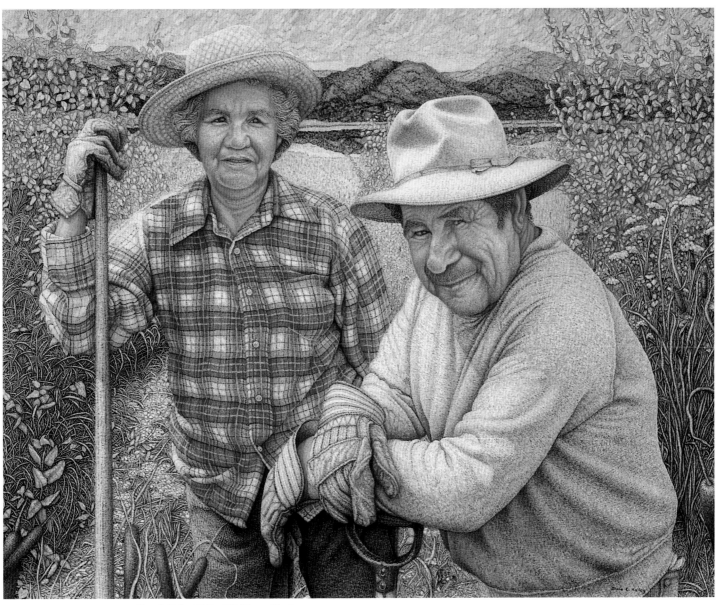

PORTRAIT OF HERMAN AND ANNA Diane E. Halley, 21.5" x 25" (55cm x 64cm)

⚡ Incorporate Details in Portraits

DIANE E. HALLEY

Over the years, Herman and Anna Hinajosa became good friends—their fifty-year-plus marriage giving testimony to love and commitment. In painting portraits, I always incorporate details because I feel they add to what the depiction says about the sum total of that person. To duplicate and paint details with texture, one must simply train the eye to observe closely. Plaid is a patterned convergence of different colored threads woven together to produce large blocks of color. I "weave" the same texture on paper that is inherent in a particular fabric. If I can borrow a piece of clothing to lay on my easel to study as I paint, it is helpful. Painting Anna's straw hat was to merely follow the weave pattern, leaving points of light where the sun shone through. When finishing the sky, I decided on joyous little yellow clouds that seemed to be bouncing upward.

↞ Create Layered Texture with Reverse Pointillism

DIANE E. HALLEY

As the narrow-gauge train on which I was riding pulled into Silverton alongside an earlier train, I saw John Coker standing and chatting with passengers. When I asked if I could photograph him for a painting he said that he, too, was a watercolorist and would be happy to pose for me. ⚯ "Reverse pointillism" is perhaps the best way to explain how I paint. To create texture I paint in many layers. I do not paint dots, but paint *around* small points of light—often making use of the nubbiness of the heavy Arches paper, with the low points of the paper receiving a heavier saturation of paint, and the high points left as the small points of light. I use a very small brush (no. 0 and no. 1), and have found that Winsor & Newton Series 7, short and stubby miniature, has a fine tip and with a very dry brush makes for controlled painting. I keep a gunnysack towel on my lap to wipe the excess moisture from the brush before I paint.

JODY'S CAT Donna Lamb, 13.5" x 25.5" (34cm x 65cm)

✤ Contrast Soft Fur Against Rough Surroundings

DONNA LAMB

While photographing a friend's cat, I was lucky to catch this graceful pose. I put a simple dark background and rough bricks behind and under the cat to emphasize its long, soft fur. ✤ Within the large, white shape, I used tints of color on the cat's body to give it form. To show the edge texture of the cat I used three techniques: painting the wet background into dampened edges of the cat, lifting small strokes from the damp background, and applying some Chinese White in a few places like the whiskers.

✤ Soft to the Touch

AMY CALLAWAY

I was immediately taken by the shadow repeating the shape of my kitten's head. The dramatic morning light was the inspiration and the detailed textures of soft fur and shadows completed the composition. ✤ Layers of light values were applied first, then more color added to obtain the rich darks. A no. 2 fine red sable brush was used to paint the very fine lines of hair. Alizarin Crimson, Prussian Blue and Burnt Umber are my favorite colors to blend shadows. White gouache was used for the kitten's whiskers.

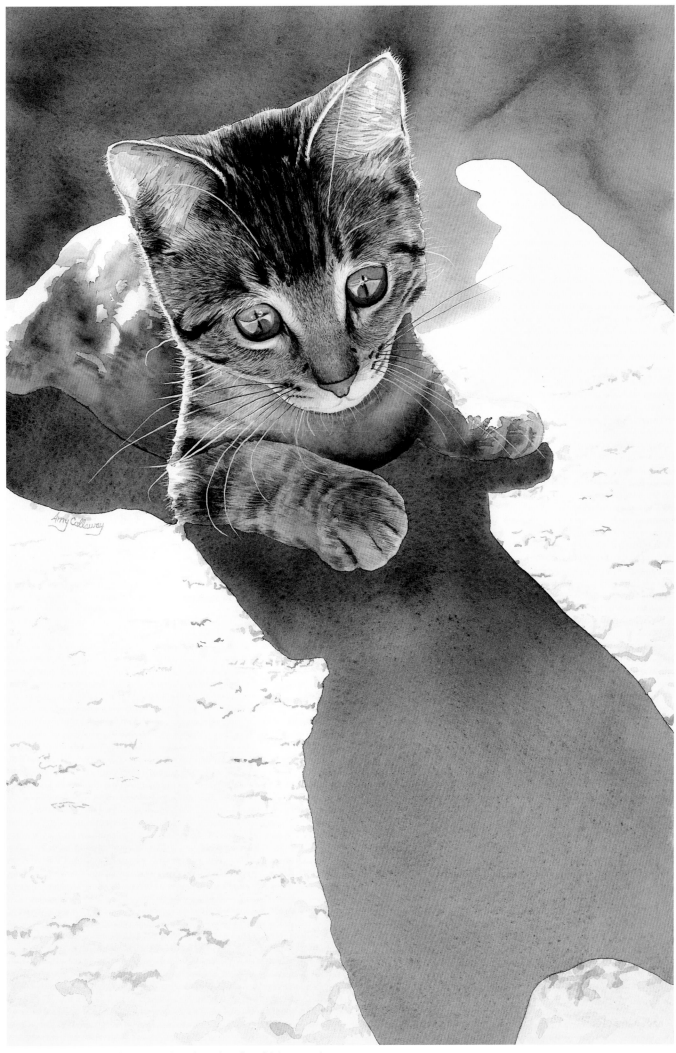

FELINE FASCINATION Amy Callaway, watercolor and gouache, 22" x 15" (56cm x 38cm)

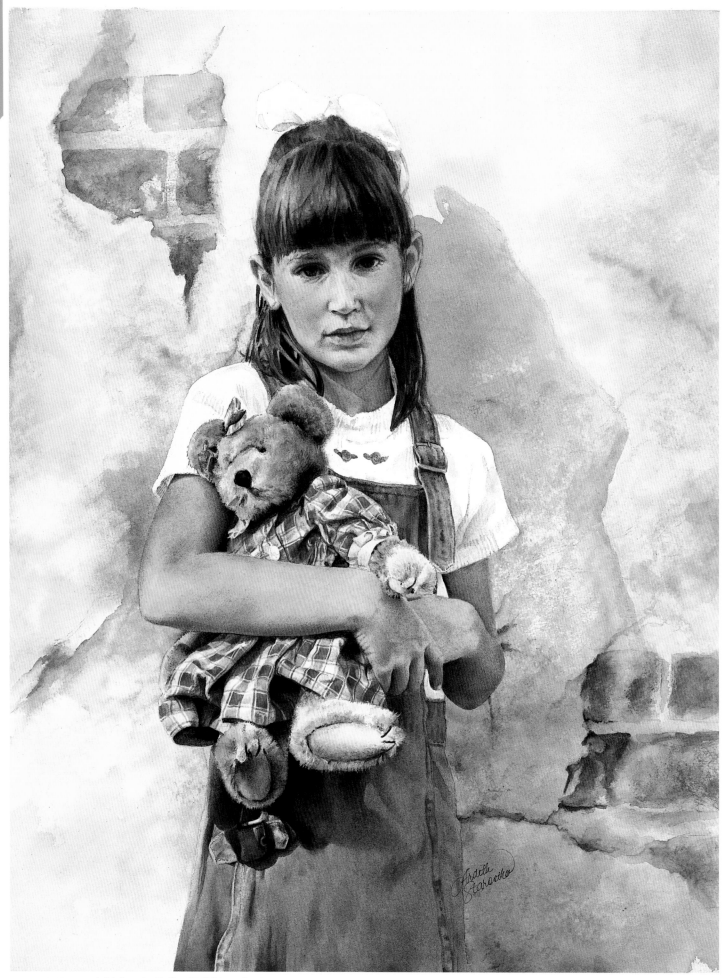

HALEY AND COMPANY Ardith Starostka, 20.5" x 15.75" (52cm x 40cm)

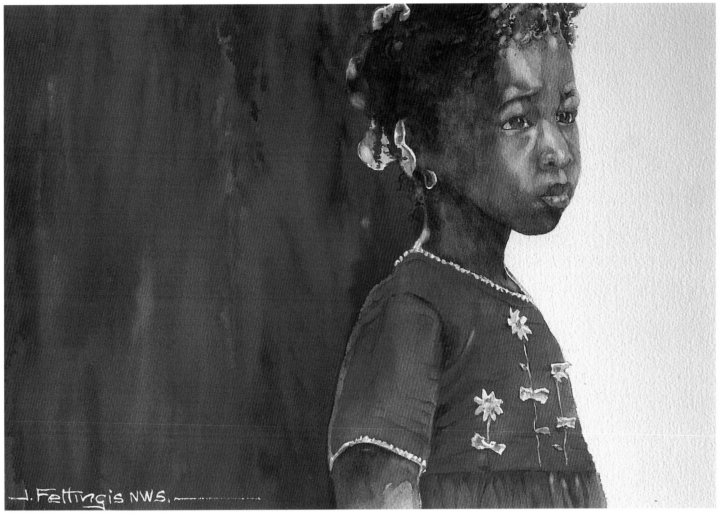

LADY IN RED Joseph Fettingis, 16" x 22" (41cm x 56cm)

♦ Strong Colors and Texture for Strong Personality

JOSEPH FETTINGIS

This little girl seemed like a lady of class, so shy and innocent. Though she was in a crowd, her thoughts were private. Because she looked so fragile, yet deep, I felt she had a strong hidden personality that should be shown with colors and texture. ♦ The painting started with cool colors as an undertone on the hair and face. After that dried, a tone of warm colors was added. This grayed down the cool colors and also allowed them to come through the warm colors, adding an interesting effect to the face. The dress and background were first painted with yellows and allowed to dry. Then, on a wet surface, a second coat of heavy creamy reds was introduced. After the colors lost their shine, yellows were again added on top of the red.

♦ Contrasting Background Textures Add Interest

ARDITH STAROSTKA

I am constantly looking for interesting backgrounds for my paintings of people. This painting is of my daughter Haley, whose school is a block away from an old Coca-Cola building. The textures of the brick and cement walls of the old building lent an excellent contrast to the smooth, soft, youthful skin of my young subject and her favorite furry teddy bear. ♦ To create the rough texture of the wall, I washed the background with an off-white color and then picked up some of the color from the paper with a damp natural sea sponge. In subsequent layers, I wet the paper and patted it, in a varied manner, with a damp sponge loaded with a darker color. I also spattered some paint and added interesting cracks by scarring the paper with the sharp end of a brush.

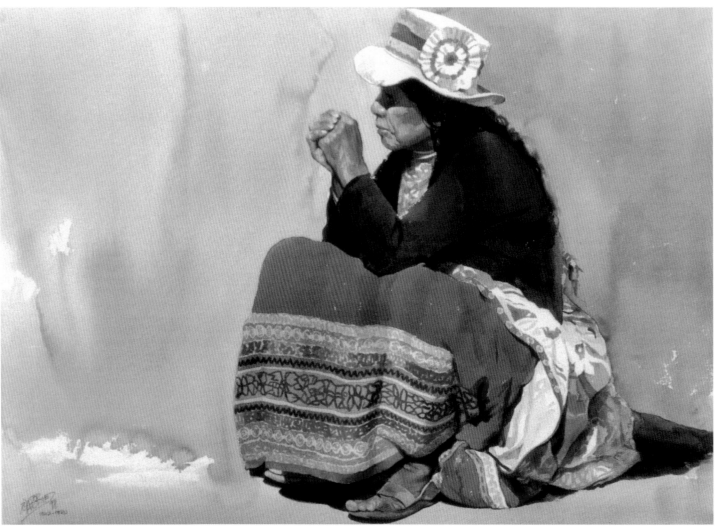

COLLAGUA—PERU Victor Martinez, 29.5" x 41" (75cm x 104cm)

⚵ Observe the Textures of Life

VICTOR MARTINEZ

Of all themes, the human figure is most appealing to me. I seek to know the outlook of the lives of people I see on the streets. While traveling, I saw a distressed woman, waiting for transportation to come. Her clothing is characteristic of Peru, in the Valley of Colca. I found interest in the different textures of her clothes, including wool and diverse fabrics. Her sandals, made out of rubber, and the tones of her olive skin presented additional qualities. ⋙ My technique is traditional watercolor; whites are from the white of the paper. The background was painted in Yellow Ochre with a 2-inch (5cm) flat brush. To create dimension in the painting, the embroidered surfaces and the folds were painted in neutral tones. The detail of the wool sweater was established by painting on a wet surface with various colors.

⋙ Background Texture Adds to "Fresco" Look

DENISE BOIE

It was with the Romantic artists of the nineteenth century in mind that I chose the style and texture of *The Visitor*. I wanted to contrast the luminous figure with the more muted background, and give the entire painting the dreamlike quality of a fresco. The simplistic perspective and limited palette give the picture unity, while the textural elements lend interest to each part of the background. Even though the focus is on the figure, the texture invites the eye to explore every corner of the painting. ⋙ Working on Masonite coated with gesso, I first applied Golden's Absorbent Ground, a new gesso formulated to accept watercolor. The basic outlines were transferred and washes of color laid in. Gum arabic was used to soften and blend edges. In the later stage of painting, bristle brushes and sandpaper were used to lift color and texturize the stone and water. Touches of opaque white highlight the pearls and scales.

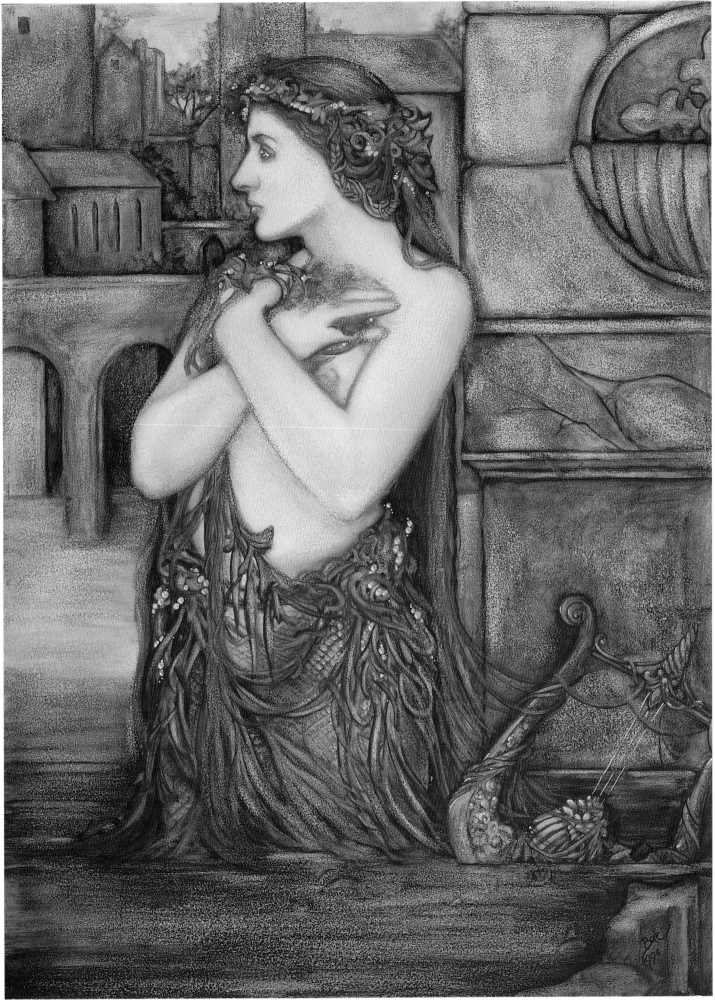

THE VISITOR Denise Boie, watercolor and gesso, 24" x 20" (61cm x 51cm)

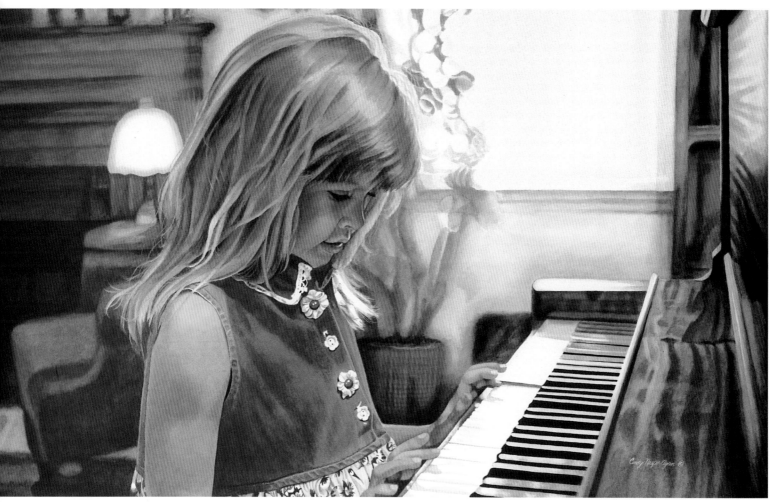

WHEN I GROW UP... Cindy Agan, watercolor and gouache, 14.5" x 24" (37cm x 61cm)

⚑ Lighting for the Warmth of Glowing Skin

CINDY AGAN

For my children's series I wanted to maintain realism throughout each piece, yet evoke emotion by capturing the softness and innocence of the children. To achieve that goal I find lighting to be most important, for the warmth of the right light can make a painting glow. ⏵ In *When I Grow Up...*, I started with the skin and hair using transparent watercolors, building up the color gradually with several glazes of color and feathering. The same technique created the texture of the wood and dress fabric. For color intensity I drybrush the finer details such as the wood grain, piano keys, buttons and flowers in the fabric. I primarily use only two brushes (no. 2 and no. 4 rounds) to maintain control. I used the white of my paper for my brightest whites but did mix in white gouache for the fine, wispy hairs.

⏩ Convey the "Inner Fabric" of a Person

PAUL W. McCORMACK

When painting a portrait, I always try to convey a sense of the individual and not just a physical likeness. Altruism was the one thing I sensed within the model's eyes, which played so beautifully against the softness of her hair and the tactile quality of the patterned fabric. The textures of these elements were achieved simply by utilizing the effect of hard and soft edges. ⏵ In painting the kimono, the pattern was masked out and then painted as plain black fabric. After removing the masking fluid, the lights and halftones of the pattern were then painted. I proceeded to glaze my halftones and darks, going over both pattern and fabric, which consequently softened the edges of the pattern.

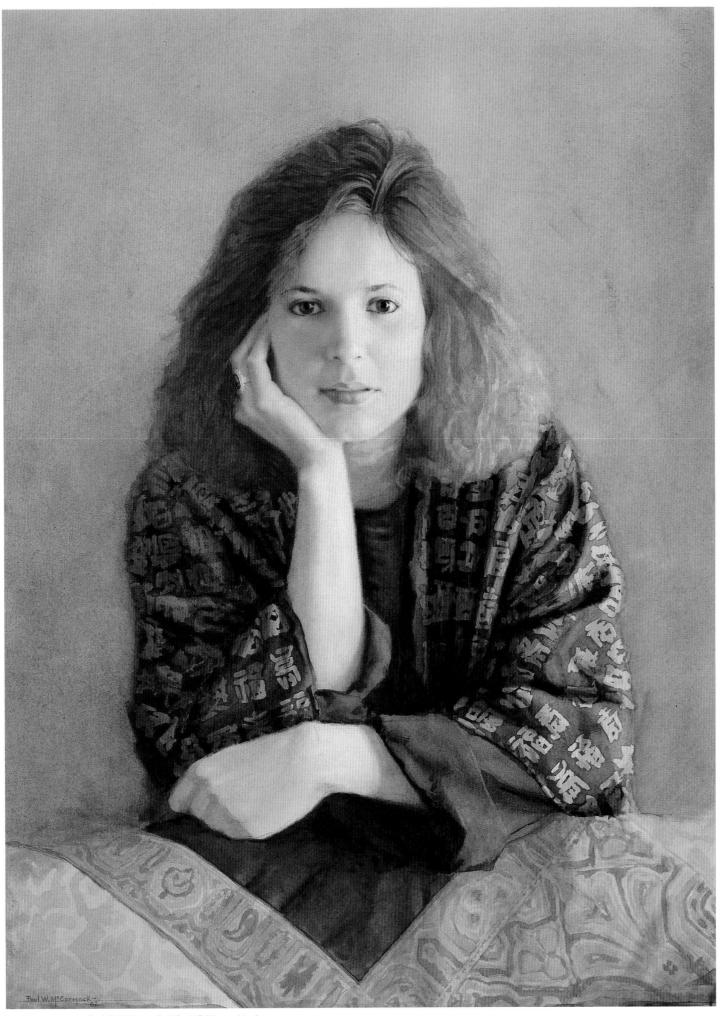

ALTRUISTIC PATTERN Paul W. McCormack, 28" x 21" (71cm x 53cm)

ON THE ROCK Susan Kathleen Black, watercolor and collage, 29" x 41" (74cm x 104cm)

Try Paper Collage for Realistic Textures

SUSAN KATHLEEN BLACK

In this painting, as in many of my paintings, I combined transparent watercolor with a variety of papers to create interesting and unique textures. Rice papers, marbled papers, tissue papers and Japanese lace papers are just some of the varieties that I use. ✑ I begin painting with transparent watercolors. There is a nearly completed painting before I start with the collage process. Then the painting seems to be lost by the time it is covered with the various pieces of torn paper. The image begins to reappear as I work back into it with the watercolors. Also, at this point, some wonderful textures and surprises begin to happen. As in *On the Rock,* I often contrast areas of straight watercolor with the collaged areas.

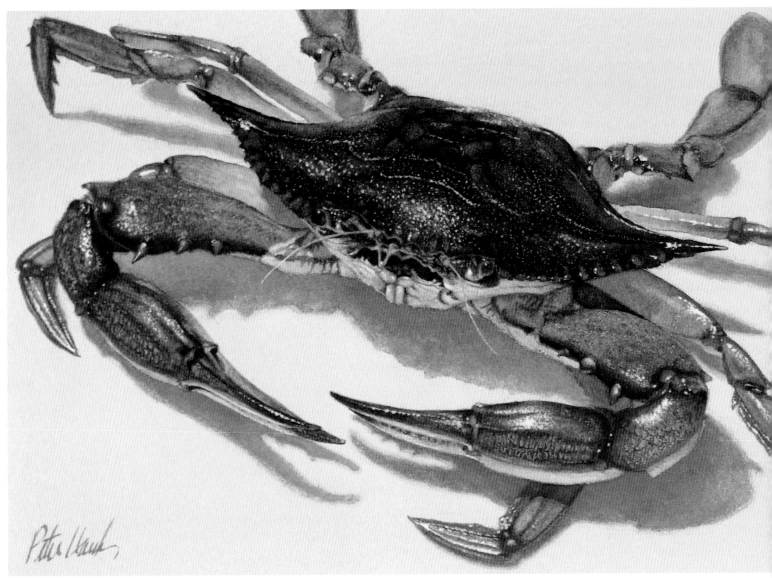

BLUE CRAB Peter Hanks, 6.25" x 9" (16cm x 23cm)

Layer Combinations of Techniques for Realistic Textures

PETER HANKS

The blue crab is not only one of my favorite foods, it is also a favorite subject of mine to paint. To me, the essence of a blue crab is its color and texture. Its wet shell can display several different surface qualities at the same time. To simplify this complex texture, I like to sort out individual textural components and group them according to their edge characteristics (soft, medium and sharp). Then in separate stages I'll render the different groups of edges, from soft to sharp, using the appropriate techniques. ✧ I first blocked in the crab's entire main shell with a rich, dark mixture of Winsor Green and Sepia. Next, I concentrated on the areas containing soft edges, and values slightly lighter than the initial dark wash, wetting and blotting with a tissue. After drying, I introduced the warm reflected color of these areas using Burnt Sienna. The lines and spots were created next—the softer-edged ones scraped and pricked with a dulled knife blade while the surface was dampened, the hard-edged ones done with a sharp blade on the dry paper.

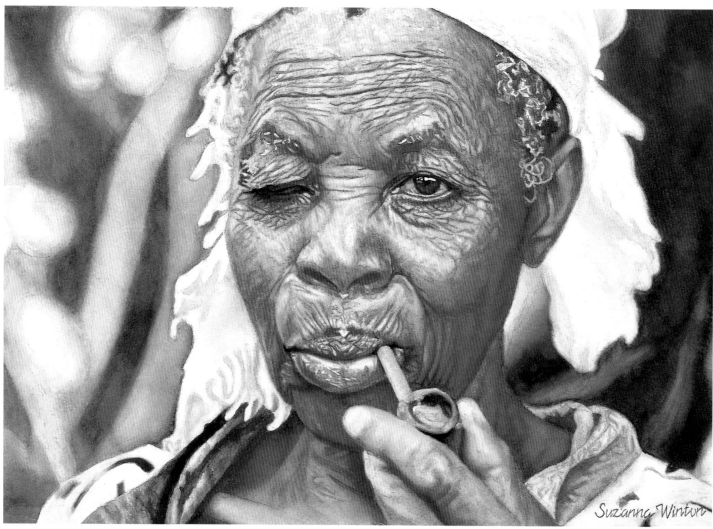

THE LADY FROM HAITI Suzanna Reese Winton, 19" x 24" (48cm x 61cm)

☂ Capturing the Soul of Your Subject

SUZANNA REESE WINTON

I love the challenge of trying to capture the human soul; it is the meaning and motivation of my work. I believe that God created each of us fascinatingly unique, both body and soul. ᴥ The texture of the skin was created by many layers of color. After the eyes were completed I worked from section to section of the face, carefully saving the highlights. Underneath the dark wrinkled areas I used a tan color and built up many layers until I finished with the darkest pigment. It is my practice to always look for the underlying colors in a subject.

↜ Observe Reflected Color on Your Model's Face

DONNA WEIDA

I could not believe the beauty and the maturity in Christian's face and eyes. I loved the reflective colors that bounced onto her face. Her wonderful braids presented a challenge to capture their fullness and texture. ᴥ I began by using the cool colors first on the face to show the shapes and shadows, then came back with the warms. I put Miskit on the braids, then used a very heavy mixture of Alizarin Crimson to paint them. In places I used some Blue Verde and returned with a mixture of sepia and violet to make the dark hair. For the background, I totally wet the background area, then dropped in creamy colors of Sap Green, Blue Verde and Ultramarine Blue and let them flow.

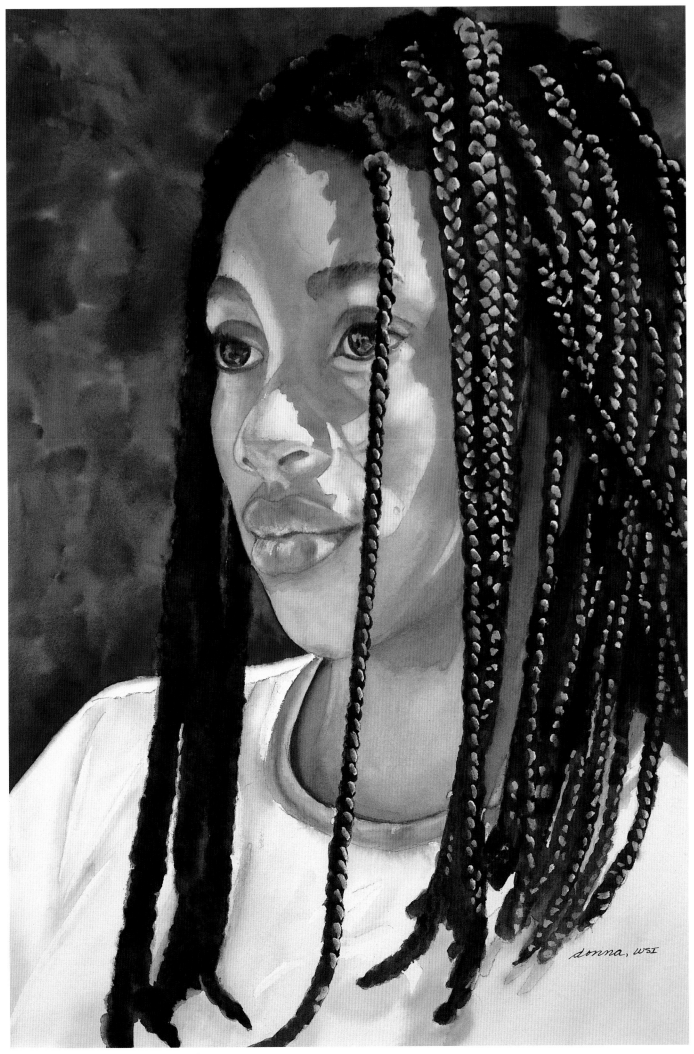

CHRISTIAN Donna Weida, 21" x 15" (53cm x 38cm)

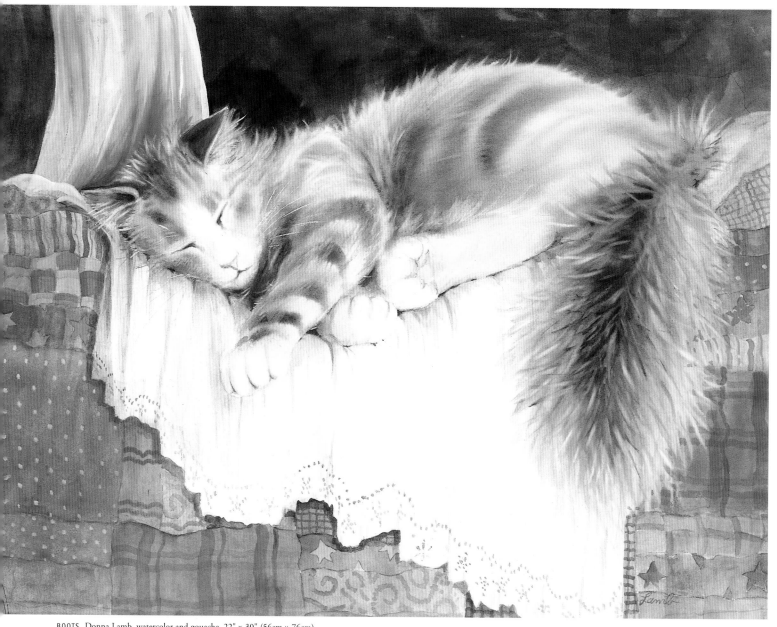

BOOTS Donna Lamb, watercolor and gouache, 22" x 30" (56cm x 76cm)

Wet-in-Wet Technique for Cats

DONNA LAMB

In painting cat portraits, I try to get the look of the cat hair and its color with wet-in-wet transparent watercolor. Using 300-lb. (638gsm) Arches cold-press paper, I wet the entire paper first and underpaint the background and shadows on the cat. I then finish the painting of the cat with layers of wet-in-wet color, drying the paper in between. The dark gray or black is a combination of Indigo and Sepia. I then paint the background, working the edges of the cat's hair by flowing the darker background into the dampened edge of the hair or by lifting the hair out from the wet background. I also lift hair from the dry painting with a stiff scrubber and sometimes use white gouache to add hairs and whiskers, or in the background.

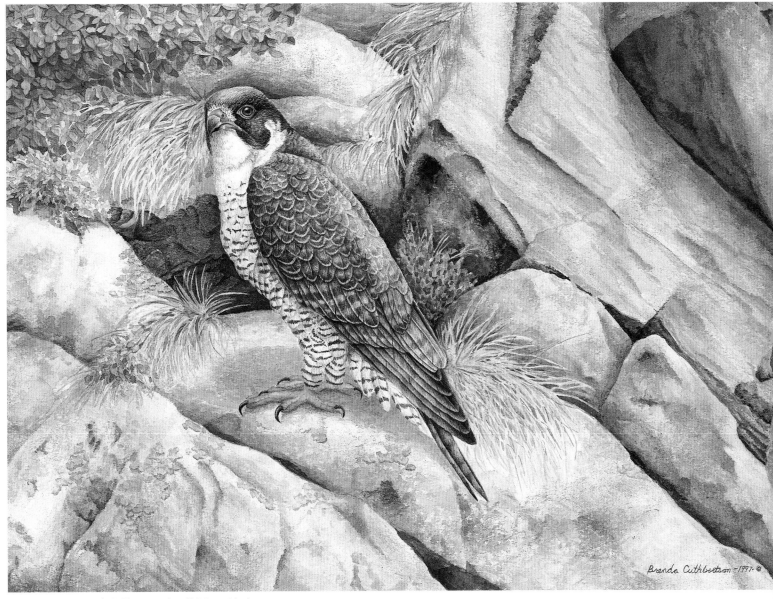

DREAM COME TRUE Brenda Cuthbertson, 10" x 14" (25cm x 36cm)

Set a Bird Against Its Natural Habitat

BRENDA CUTHBERTSON

Dream Come True was inspired by a trip to Bon Echo Provincial Park in Canada where there is a program to reestablish the peregrine falcon on the majestic Mazinaw Rock. I wanted to contrast the textures of the Precambrian rock with the soft feathers of the falcon. I always start with a very detailed drawing that I transfer to my watercolor paper. I then work back and forth from foreground to background to create the balance I want. The rock surface was painted using a dry-brush technique. I scrubbed the brush across the paper to pick up the paper's texture and create abstract shapes. I then accented the abstract shapes to create the bumps and cracks in the rocks. The peregrine falcon was painted very precisely using a no. 1 sable brush. I used Indigo on the falcon because of its warmth.

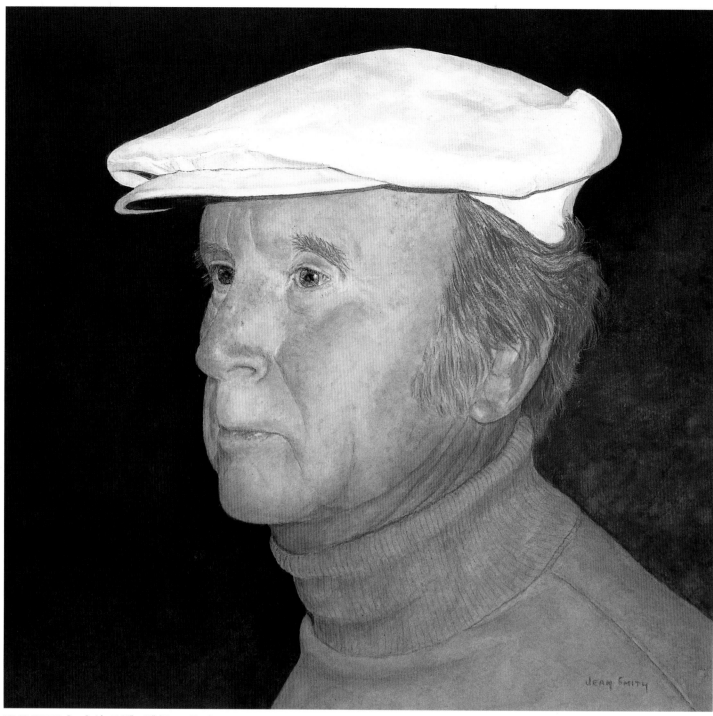

OFF TO THE TEE Jean Smith, 11.25" x 12" (29cm x 31cm)

Soft Colors and Soft Shadows Capture Personality

JEAN SMITH

"Hope springs eternal" is seen through the eyes of this avid golfer (my husband) as he goes "off to the tee." The expression as seen through the eyes, the natural facial lines and the skin tones provide the texture for this portrait. The contrasting colors in the white hat and dark background add depth. When I paint portraits, the use of soft colors and soft shadows helps capture the personality of the subject. ☙ My basic colors for skin tones are Cadmium Yellow Light, Permanent Rose and Oxide of Chromium. I added Burnt Sienna, Alizarin Crimson and mauve to the base color to capture this particular skin tone. I paint the eyes first, after preparing the face with a light wash of skin tone. I turn portraits upside down when I need to concentrate on lines and forms. The hair is created with watercolor pencils. After the portrait is completed, I add a thin line of matte medium around the portrait to prevent the portrait colors from bleeding into the background. Finally, I add the background.

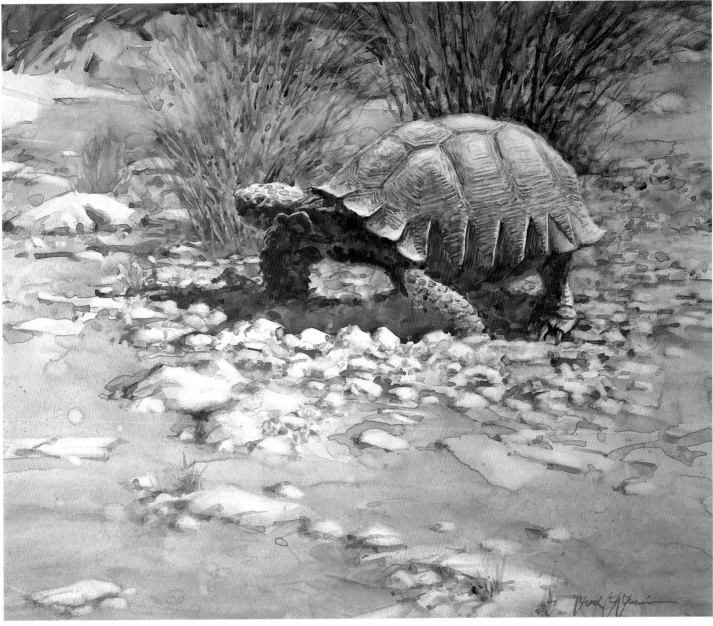

DESERT TORTOISE Frank LaLumia, 20" x 24" (51cm x 61cm)

Try an Oil-Painting Way of Thinking

FRANK LaLUMIA

I saw this desert tortoise in Joshua Tree National Monument in Southern California. I followed him, sketching all along the way. I stopped only when he started to get stressed by my presence. I was fascinated by his texture, which was like a window on millions of years of time. The rugged armor of his shell and the plate-like covering on his body reminded me of a knight riding off into battle, albeit at a somewhat slower pace and with less sinister intentions. ◦ I saw this wonderful textural challenge as a drawing problem. The materials used were chosen to give more flexibility to the drawing process. I worked on rag bristol, a five-ply plate surface. This heavily sized surface allows greater lifting, as well as an added opportunity to soften and work edges. In addition to my normal palette (a warm and a cool of each primary), I added Permanent White. I used the white in the paint mixtures—not to paint the lights, but to allow the mixtures to be more easily moved around, lifted and altered. It is an oil-painting way of thinking, and it comes in handy when confronting a particularly complex drawing problem.

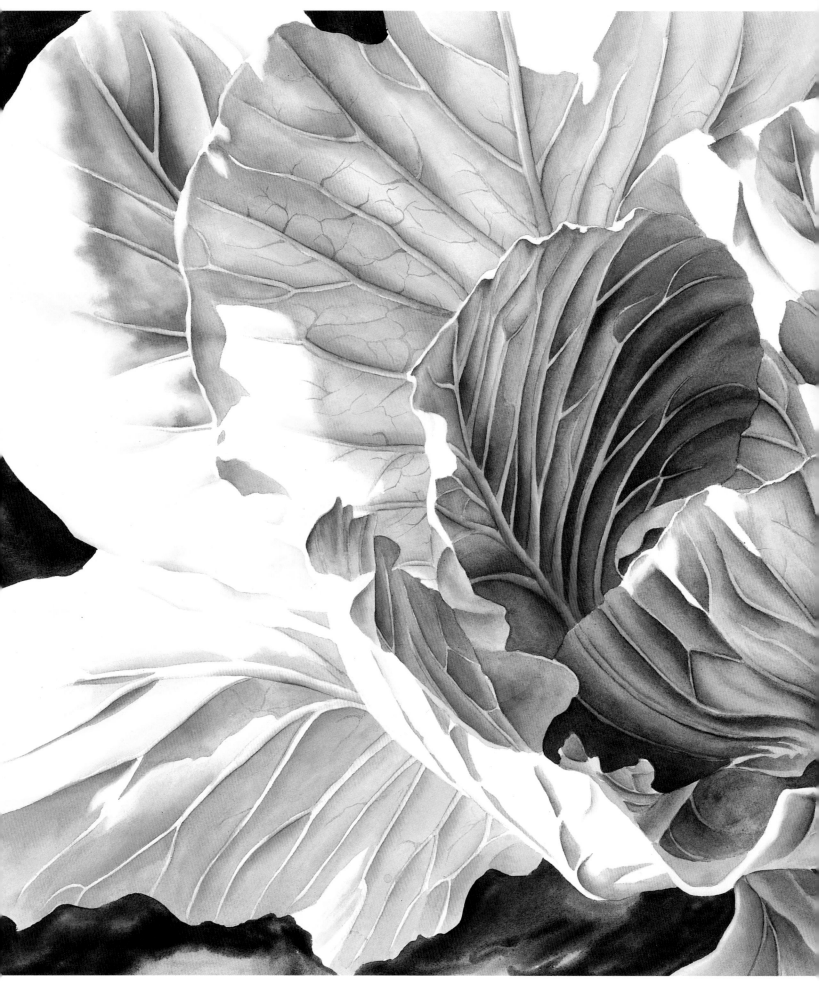

CABBAGE SUNLIGHT Monika A. Pate, 20" x 28" (51cm x 71cm)

monika Pate

I spent considerable time studying and photographing this cabbage during one sunny summer day in Iowa. However, I waited for over a year to take on what I perceived as being the difficult task of painting it. I especially liked the effects of backlight on the cabbage because it revealed the texture of the foliage, and my formal training as a biologist enabled me to better understand the subject. My favorite technique is glazing. Desired colors and values are achieved by applying multiple layers, allowing me to gradually build colors and values. Sometimes I paint dark over light and at other times I reverse the process. I seldom use special techniques to create various textures. Instead, I usually rely on my brush and my ability to analyze and interpret the essence of a subject.

—*Monika A. Pate*

conveying the textures of

light

and weather

BACK FENCE LIAISON Judy Jones, 20" x 25" (51cm x 64cm)

✿ Match Your Pigments to Your Subject

JUDY JONES

Like most artists, I am a sucker for light. The textural surface quality of an object determines how light plays across and through that object. To capture the textural reality of my subjects, I am very purposeful in my selection of pigments. ✒ I begin by using adjectives such as soft or hard, shiny or matte, translucent, grainy, fluffy, velvety, etc., to describe each object. I then carefully match the physical properties of each pigment to the textural surface quality of each object. The dahlias above are soft, smooth and somewhat translucent; therefore, I used transparent pigments (Daniel Smith's Quinacridone Coral, Quinacridone Pink and Aureolin Yellow). Many glazes, applied wet-in-wet to each petal, created gentle value transitions, further describing their softness and smoothness. In contrast, I used opaque sedimentary pigments (French Ultramarine and Burnt Sienna) to define the nonreflective, hard-edged fence. Direct painting, wet-on-dry, and drybrush speak of its rougher nature. Combining objects with diverse textural qualities enhances the characteristics of each.

➳ Contrast Textures to Create the Touch of Light

GWEN TALBOT HODGES

The contrasting textures on this garden path help create the atmosphere of *Light Breaking Through*. Thick, opaque layers of paint next to thin layers or completely untouched areas of paper make it easy to see the light. If light is the spirit, then texture adds the soul. Textural contrast is seen in the subject matter itself with the sturdy, rough planks of wood supporting the delicate, translucent plants. ✒ I begin by saving the white and light areas with masking fluid. This allows me to be free to drop in, spatter and sling paint into the shadowy darks. I pushed the contrasting rough texture on the crosscut section of wood by building up many layers of color, then dropping in fluorescent gouache.

LIGHT BREAKING THROUGH Gwen Talbot Hodges, watercolor and gouache, 28.5" x 20" (72cm x 51cm)

RAINY DAY IN SAANEN Mark A. Collins, 18" x 27" (46cm x 69cm)

♦ Let Underlying Color "See" Through

MARK A. COLLINS

On a gloomy afternoon while traveling in Switzerland, I did not have high hopes of finding subjects to paint. But the warm glow of light from a second-story shop window captured my attention and lent an aura of mystery. Who is responsible for giving the building its periodic face-lift? The variety of textures suggesting a combination of years of attention and neglect was intriguing. ⮞ A significant challenge in this painting was to make the wood appear wet. Although the weathered siding looks uniformly gray or brown, there are strong washes of Cobalt Blue, Winsor Violet, Quinacridone Gold and Quinacridone Burnt Scarlet lying beneath the weathered wood. This foundation "seeps" through the final layers to varying degrees, suggesting places where more moisture collects or lingers after the rain. As a final step, paint and water were applied in the same manner that I imagined moisture would travel along the façade.

⮞ Light Provides Texture in Transparency

GWEN TALBOT HODGES

Unusual shapes and patterns of light that shine through the fine texture of transparent objects fascinate and inspire me. Sometimes the shadows of this world seem to overwhelm the beauty and happiness in our lives. Amidst these transparent veils is the light of hope that comes shining through. ⮞ On 300-lb. (638gsm) Arches paper, I layer colors wet-into-wet beginning with yellows and reds. As I work around the color wheel using the most transparent primary colors, the secondary hues are formed naturally. I repeat this process many times until the desired intensity or value is reached. Tossing in a little salt adds a subtle sparkle and interesting depth to the luminous glazes. After the masking fluid is removed, a scrub brush is used to soften and smooth the rough edges and to lift out and blend certain areas. Finally, just a touch of fluorescent gouache gives an added brilliance and luminosity.

HOPE SHINING THROUGH Gwen Talbot Hodges, watercolor and gouache, 30" x 21.25" (76cm x 54cm)

SUN DRENCHED Ann Gaechter, 18" x 28" (46cm x 71cm)

⚭ Create Inviting Depth With Rich Darks

ANN GAECHTER

Every living thing inevitably moves on past the summer of life, and this sunflower reflects this mystery of passage. The luminosity of the intense light on the remaining petals contrasts with the rich, dark texture left behind after the seeds have fallen. Complex darks add mystery and texture to the intriguing play of light, shadow and detail, causing light-filled areas to jump off the page. ❧ To create the luminous texture and depth in the sunflower's head, I used very saturated, creamy mixtures of Burnt Sienna and Burnt Umber, with Permanent Alizarin Crimson, New Gamboge and Payne's Gray added at different times according to my light source. I used a modified impasto method, more commonly used in oil painting, to lay down these darks. To keep the deep colors illuminated, I layered them over glowing transparent glazes of yellows and reds.

↦ Angle of Sunlight Enhances Texture

MONIKA A. PATE

Painting still lifes in natural light gives me the opportunity to explore various textures. The angle of the sun makes a big difference in the appearance of the textures. Objects used for *Lemon and Lace* looked especially interesting in the late afternoon. The effects of sunlight enhanced the texture of the flower petals and created an interesting value range in the lemon. The sunlight also emphasized the smooth, curved surface of the ceramics. The soft simplicity of the delicate lace contrasts with the more complicated texture of the other objects. ❧ The texture of the ceramics was painted using layers of warm and cool colors. Since the ceramic surface has a matte finish, after the colors dried I used a damp, stiff brush to lift some paint and achieve the soft look. I also used this technique on the lemon to lighten some areas. To create the texture of the lemon, I first applied dark, cooler colors and then layered the yellows and yellow-oranges over them.

LEMON AND LACE Monika A. Pate, 21" x 23" (53cm x 58cm)

SEVENTH AVENUE VENDOR, NYC John T. Salminen, 33" x 39" (84cm x 99cm)

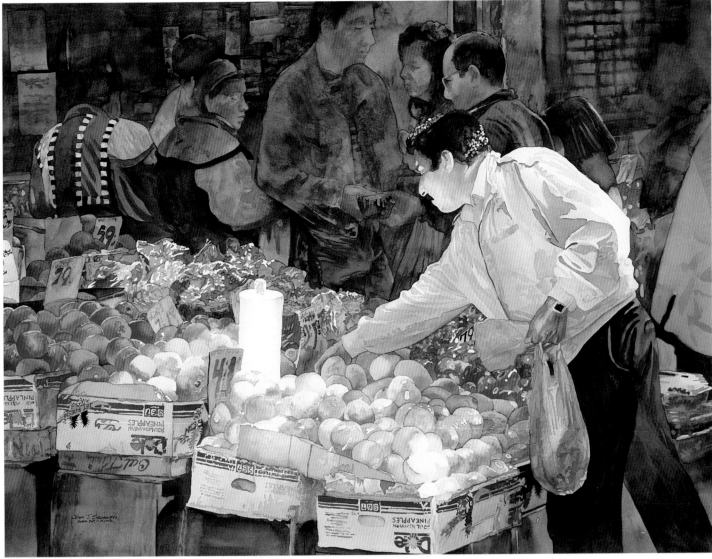

BRIGHTON BEACH MARKET, NYC John T. Salminen, 25" x 35" (64cm x 89cm)

⚡ Contrast Light Foreground, Dark Background

JOHN T. SALMINEN

The texture or "feeling" of light is the main theme of this painting. Our interest is first drawn to the action and colorful produce in the foreground; afterward, we are attracted to the mysterious darkness of the background. ✍ The tremendous amount of detail in this painting had to be carefully organized. If everything in it had been treated equally, confusion would have resulted. The solution was in the organization of the values: High contrast commands more attention and low contrast (closely related values) recedes. The purple-yellow complementary mix in the background was echoed in the reflected light of the main figure's jacket.

⚡ Contrast Dark Foreground, Light Background

JOHN T. SALMINEN

The texture of light also plays the starring role here—the welcoming warmth of the pizzeria as opposed to the lonely, cold street. Color temperature contributes to this contrast, as does painting texture. The vendor and his table of T-shirts are sharply focused and hard-edged while the interior is soft and indistinct. The dark silhouetted figure of the vendor draws our attention. ✍ The dark values in the foreground are a mixture of Alizarin Crimson, Thalo Green and Thalo Blue. Normally I would not add blue to this mixture, but the resulting color appeared cooler, and the desired effect was to maximize the contrast between the vendor and the pizzeria interior.

STEEPHILL, LINCOLNSHIRE Linda S. Gunn, 22" x 30" (56cm x 76cm)

�258 Pour the Light Onto Your Paper

LINDA S. GUNN

Steephill, Lincolnshire was inspired by photographs and references from my personal journal of travels in England. The techniques were carefully planned and executed in a precise sequence, even though the painting gives the appearance of being loosely painted. I enjoy completely covering the paper with pigment painted or poured over the masked whites. The remaining white paper creates a powerful value contrast that can be softened to look like glowing light or left to sparkle as highlighted cobblestones. ◆⟩ First, I masked only the elements of the composition that were to remain white. Then, having mixed large amounts of Aureolin Yellow, Alizarin Crimson, Cobalt Blue and Ultramarine Blue, I painted a bull's-eye on the very wet paper using a large round brush. (This technique belongs to artist Nita Engle.) I repeated the masking and bull's-eye technique twice more, each time saving the lightest value. My favorite tool for softening the hard edges left after removing masking is a Robert Simmons Fabric Master scrubber, which is a short, stiff, white-bristled fabric-painting brush.

◆► The Texture of Refracted Light

GWEN TALBOT HODGES

The refracted light and color through the hard, smooth sheen of transparent glass that supported the stems and soft, delicate petals in clear water was my source of inspiration and challenge. Coming in closer to my subject added focus to the texture and allowed more involvement with the feel of the objects. ◆⟩ Masking fluid was applied to the white and lightest shapes. After wetting an area, I dropped lots of color. When dry, the mask was removed and I used a stiff brush to soften and blend the hard, rough edges. The key to painting the fine texture of glass is value. You must have a full range from pure white to very dark darks. The subtle use of salt helped achieve the effect of moisture at the top of the vase and contributed to the overall harmony and radiance of the painting.

FACETS OF FULFILLMENT Gwen Talbot Hodges, 30" x 18.5" (76cm x 47cm)

IN THE REALM OF KINGS Dona Abbott, 7" x 25.5" (18cm x 65cm)

↕ Rainy Weather Reveals Earthy Textures

DONA ABBOTT

I was returning from photographing a lighthouse along the coast of Oregon when it began to rain, muting the landscape into a somber gray. Underneath a massive spruce tree, I spotted this cluster of hens and roosters—a visual treat that halted my footsteps. No longer worried about getting wet, I crouched to observe, photograph and enjoy the moment. ✎ Later, in the studio, I combined elements from several of the photographs. Using 300-lb. (638gsm) Arches rough paper, I flooded strong colors into the wet background, allowing them to blend on the paper. The shapes were easy to paint around, but I used masking on larger white spots and drybrush to give softness to neck feathers. Scratches with a knife tip suggested feathers on the white birds. A warm glow on their breasts captures light reflected from the ground. The initial foreground wash was graded from warm to cool. Before it dried, I scratched it with a brush tip to establish a textural feel.

↝ Celebrate Light Shapes as Texture

JUDI BETTS

Texture and shape are combined in my paintings. I use shapes to create texture; to form configurations. My texture consists of planned, carefully orchestrated light shapes, directing the eye toward the center of interest. These small "magical shapes" create a kaleidoscopic maze of texture—repetition with variety. This feeling is accentuated by contrasting integrated configurations of textural flat shapes against open areas of graded washes. These configurations appear fractured when compared to graded washes. The whole effect forces my large white shape, the burro, to stand out because of its lack of texture. ✎ To maintain a feeling of heat and sunlight, I chose a high-keyed value plan using New Gamboge, Rose Madder Genuine and Quinacridone Coral. Some shapes were defined by scrubbing color out using three-by-five-inch cards and a small natural sponge.

BUENOS DIAS Judi Betts, 22" x 30" (56cm x 76cm)

AZALEAS Allen Faxon Gardiner, watercolor and acrylic, 22" x 19.5" (56cm x 50cm)

WABASH STREET, CHICAGO John T. Salminen, 33" x 39" (84cm x 99cm)

↨ Let Cool Colors Dominate on an Overcast Day

JOHN T. SALMINEN

In this painting, the elevated train structure is massive and solid, while the surfaces of the girders and the steel plates are pocked with delicate textural patterns. The design was derived from the solidarity of the massive forms. The delicate texture on the surfaces serves to reinforce the scale and size of the structure. ⌐ This painting was done in a blue-orange complementary color scheme. The steel girders were painted with varying mixtures of Davy's Gray and Manganese Green. This dominant cool combination enabled the red-orange to achieve maximum impact.

↤ Acrylic Texturizes Background

ALLEN FAXON GARDINER

Flowers make excellent subjects for watercolor. In *Azaleas*, the dark, textured background complements the bright blooms. ⌐ To create texture in the background, I laid in a wash of yellow-green acrylic. On top of this I floated a thick watercolor mix of dark green. I then worked back in with a brush and paper toweling, allowing the yellow-green acrylic to show through in spots, creating interesting shapes approximating out-of-focus foliage. I work exclusively on regular surface bristol. I do very little blending, preferring to float color on the paper with some layering to create sharp edges that give the foliage texture where none exists. Bristol lends itself to this technique.

This painting was inspired by experiencing the warmth at the bottom of the Canyon de Chelly on a cold, windy day. The textured walls catch and absorb the Arizona sun, making them warm to the touch. This spiritual place has been an artistic inspiration to the ancient ones who first used the walls as a canvas and to the many present-day artists and photographers who visit it annually. Referring to my sketches done on location, I began this painting by sprinkling the paper with powdered charcoal followed by a spray of water to suggest texture. After drying, I sprayed it with fixative, then coated it with acrylic medium. I then alternated glazes of cools and warms, enhancing the shapes with charcoal pencil to capture the color and texture of the red sandstone walls. The last step was painting the sky, windows and linear crevices of the ruins in a complementary color.

—*Gerry Grout*

disclosing the textures

of the **spirit**

SPIRITUAL PLACE OF STONE Gerry Grout, watercolor, acrylic and charcoal, 22" x 30" (56cm x 76cm)

GENESIS Helen Bond, 23" x 18" (59cm x 46cm)

HOT SUMMER NIGHT Gayle Denington-Anderson, watercolor and acrylic, 22" x 30" (56cm x 76cm)

✦ Textural Contrast of Void vs. Mass

GAYLE DENINGTON-ANDERSON

When I am painting my "spacey" works, I like to play up the contrast between the vast emptiness of space and the solidity of the forms that appear there. With this particular subject matter, great contrasts in value, hue *and* texture occur naturally, or so one supposes. ✦ For my space-related works, to create the effect of solid objects in a vast, amorphous field, I use very loose, wet watercolor for the "space" sections, and try to include some hazy, undefined edges. Then, for objects such as planet surfaces, I often use acrylics. The contrast in the two mediums plays up the contrast in subject and background nicely, making the subject area appear more massive and solid. Sometimes I even use textural paint of various kinds, stamping it with round objects to suggest the craters in three dimensions. Here, though, I simply use heavy acrylic with some buildup of paint to indicate the rough surface of the "planet."

✦ No-Brush Technique Emulates Nature's Movement

HELEN BOND

In the creation of *Genesis*, I attempted to capture light exploding through the earth's substance leaving gentle patterns and shadows. The watercolor lift technique that I used allowed me to bring the spirit of nature's forms to life. ✦ I painted *Genesis* on Crescent illustration board, applying liberal amounts of the primary colors to a wet surface, each color overlapping the others. I placed a piece of heavy-gauge vinyl cut to the size of the board over the paint. With purposeful movements of the vinyl, I formed unique textures and patterns. It is a one-step process that engages all of one's creativity in the moment.

GOLDEN GATE BRIDGE II Suzanne Welch, 22" x 30" (56cm x 76cm)

Fog Adds Mystery to the Ordinary

SUZANNE WELCH

In *Golden Gate Bridge II,* the heavy fog that veils the hills on the opposite shore also subdues the values, limiting the range of darks and lights. These middle values are achieved with soft grayed blues, while the brighter red beams emerge toward the viewer through the fog. The illusion of texture is created by controlling the varying density of paint application, in combination with the use of selective details, which are strongest on the beams closest to the viewer and become increasingly obscured with distance. ◄ Because of the unusual symmetry of the viewpoint I chose to paint, I was especially careful cropping my subject, and used very detailed preliminary drawings to analyze the composition. I then created an underpainting of blue, glazed with warmer (brown) and cooler (violet) variations, and built upon this to achieve the final value relationships. I added glazes of yellow, orange and red to attain the depth of color in the completed painting. Liquid frisket was used on parts of the roadway overhead and on the larger rivets.

SIOUX TRADITION Julie Christiansen-Dull, 14" x 20" (36cm x 51cm)

Sioux Beads Represent a Living Mosaic

JULIE CHRISTIANSEN-DULL

On a visit to the Buffalo Bill Historical Museum in Cody, Wyoming, I marveled at the intricate beadwork of the Sioux moccasins resting on a ceremonial robe, bordered by a painted parfleche and feathered pipe. With designs and colors, the Sioux symbolized their mysticism: triangles for arrows or tipis, white for purity, navy for victory, sky blue for water and sky, green for life, red for wounds and "trail on which woman travels." I designed the painting with dark triangles on the right side to reflect the near destruction of the Native Americans' culture and existence. The beaded robe continues beyond the paper, representing their enduring spirit. ✒ To preserve the dancing light of the beads that still seemed alive, I painted the beadwork like a living mosaic. I did not use masking. Using a no. 2 brush, I saved white for sparkle, brushed tiny strokes and glazed dark colors against light.

PAMELIA Paul W. McCormack, 70" x 40" (178cm x 102cm)

TRIBUTE Sally Cays, 22" x 30" (56cm x 76cm)

☀ Textural Opulence Reflects Cultural Richness

SALLY CAYS

As its title suggests, this painting was done as a tribute to a fundamental part of my heritage. The parchment scroll of the old Torah with its white satin cover had been smuggled out of Eastern Europe to save it from destruction during the Holocaust. The red velvet of its newer cover, adorned with gold threads and sequins, spoke to the deepest memories of my childhood. All of these textures—old wood, parchment, brass, silver, velvet, satin, metallic threads and gold cord—create the textural opulence that reflects the rich culture of an ancient people. ☙ The texture of the velvet was made by placing paint in the darkest part of each shadow area, then, with a brush wet only with water, quickly dragging color out to gradually fade into light, feathery edges. This had to be done while the paint was still wet by utilizing a very controlled wet-in-wet technique. After all the shadow areas had thoroughly dried, I glazed over them with Winsor Red.

☚ Texture Creates a Mood

PAUL W. McCORMACK

In *Pamelia* I was fortunate enough to work from life, which in turn led me to a flesh palette of Yellow Ochre, Rose Madder Genuine and Cerulean Blue. The opaque and transparent qualities of these particular pigments tend to separate on the paper's surface, causing a very subtle textural effect of warm and cool colors. With the addition of Cadmium Red Light, these colors are indispensable to me when it comes to painting the figure. ☙ Many of my students ask me how to create certain textures, such as the shine of brass or silver, the softness of someone's hair or certain types of fabric, and my answer is always the same: correct color, value and proper treatment of hard and soft edges.

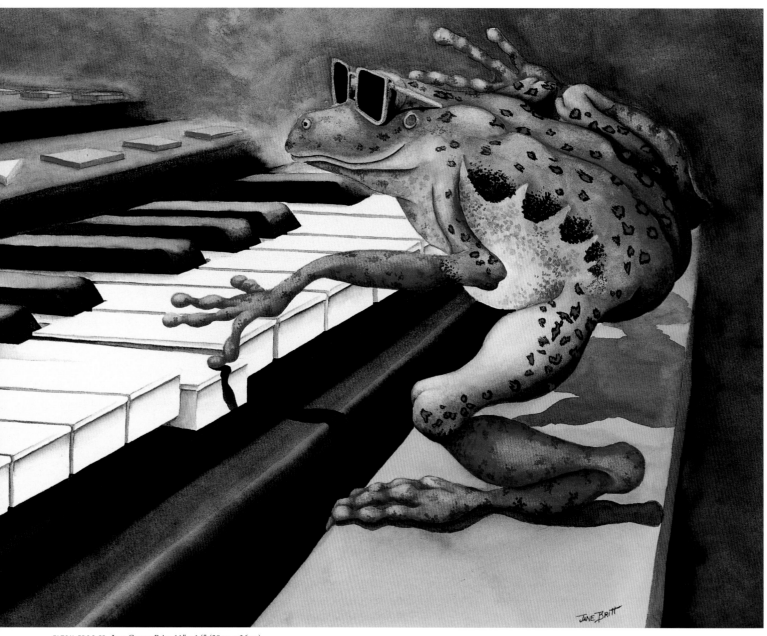

ELTON FROG II Jane Carson Britt, 11" x 14" (28cm x 36cm)

⚑ Paint the Texture of Humor

JANE CARSON BRITT

I want my paintings to bring a smile to the observer. Although my paintings are of a whimsical nature, I am also a realistic painter, and texture is an important part of realism. Even though the frog is playing the piano and wearing sunglasses, I wanted to paint the texture of his skin and the lumpiness of his body realistically. ◄ I use deep, rich colors in my paintings and lift my color off where I want lighter values. The spotty texture of the frog's skin was applied with a no. 2 brush by dotting darker colors over the first layers of dried color. The dots follow the curves and lumps of the frog's body.

↦ Develop an Imaginative Setting

DEAN DAVIS

Shape, movement and color dominate my work, but to maintain viewer interest, texture decorates the shapes, entertaining with a close, more intimate look. Texture in this painting was achieved with painted lines, dots and symbols relating to the area portrayed. These lines and signs also create movement throughout the rectangle. My approach to painting, often labeled "whimsical," is semiabstract, using recognizable objects in an imaginative setting (in this case, a zipper closing the San Andreas Fault). ◄ Using gouache and watercolor on hot-press paper allowed me to *create* visual texture rather than rely on the paper roughness. Techniques used were wet-into-wet, stamping (stencil brush), spatter (loaded "bright" flicked with my finger) and masking. Then lines and symbols were painted in several layers with a no. 4 sable.

SAN ANDREAS ZIPPER Dean Davis, watercolor and gouache, 21" x 18" (53cm x 46cm)

RED SERIES #5 Joan A. Burr, 22" x 19" (56cm x 48cm)

FEBRUARY Carolyn H. Pedersen, watercolor, gesso, gouache and ink, 22" x 30" (56cm x 76cm)

♠ Express Yourself With a Textured Focal Point

CAROLYN H. PEDERSEN

February was inspired by lines left on the beach after a receding storm. It was a magical experience; the painting seemed to almost paint itself. I had found a way to express rather than report what I was feeling. ❧ In this painting the textured focal point was achieved by wetting a path on the paper and spooning on the pigment from a jar while tilting the paper. Extra water was added to encourage some of the runs. I used earth tones and sedimentary colors and in some cases mixed them with ink.

♠ Visualize and Create From Within

JOAN A. BURR

I enjoy experimenting and selecting colors for their strong chroma. I am surrounded by reds and golds here in Arizona, and that is reflected in this work. Seventy-five percent of this painting was executed without a brush. This has become an exciting, challenging way of working, allowing me to create from within. ❧ Reds, yellows and browns were liquified and applied with a squirt bottle. I visualized a waterfall, tilted the paper and sprayed it with Pam. To simulate falling water, white lines were added with a dispenser adapted with a flow-through needle commonly used for solvents. The sky was painted negatively with a brush around the top land formation.

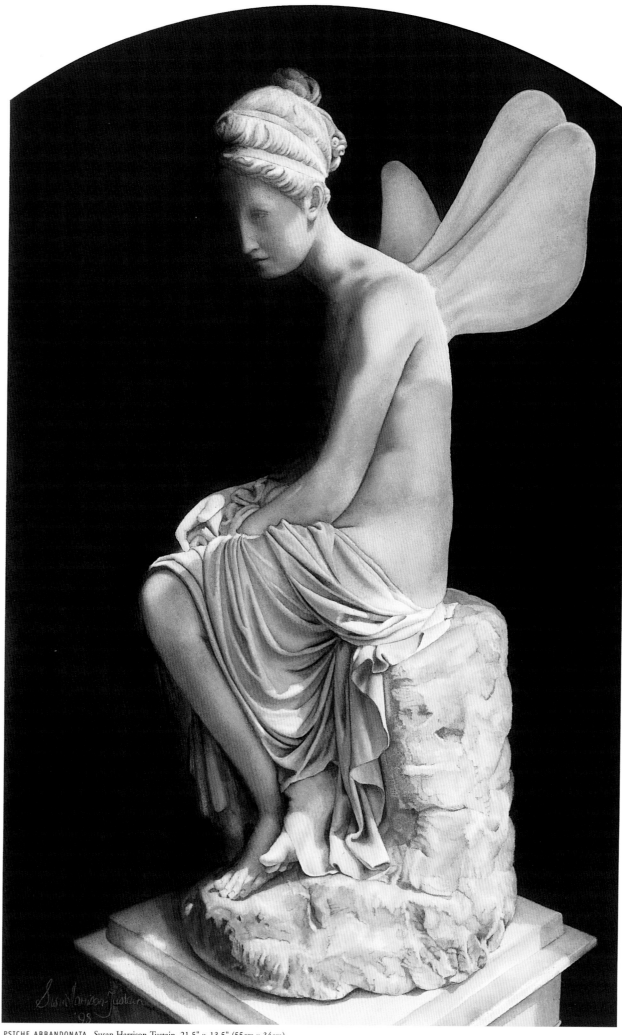

PSICHE ABBANDONATA Susan Harrison-Tustain, 21.5" x 13.5" (55cm x 34cm)

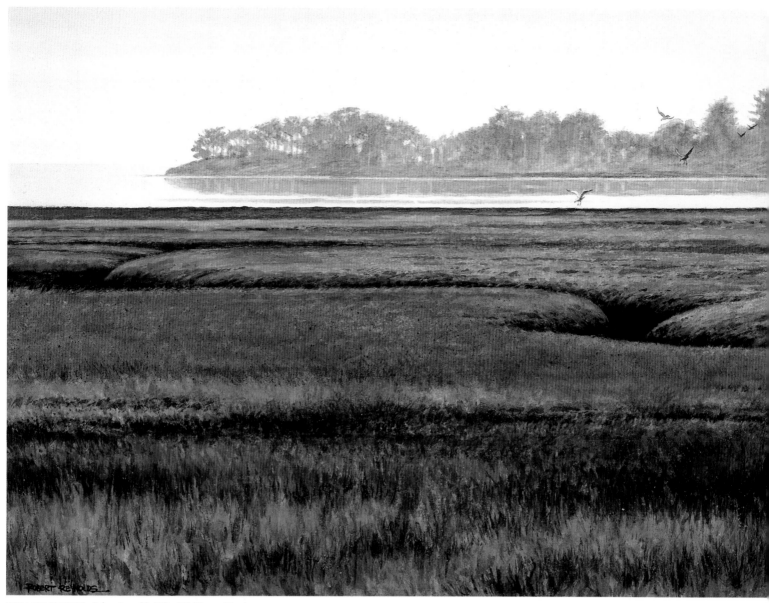

TIDE LAND TAPESTRY Robert Reynolds, 20" x 28" (51cm x 71cm)

⚡ Create a Language of Texture

ROBERT REYNOLDS

When I first viewed this nearby coastline subject, the vegetation reminded me of a rich blend of colors and textures one would find in a beautifully woven tapestry. Because the textures were defined by the various kinds of vegetation, each at different stages of growth, all were reacting to the light in their own unique manner. To capture this image without rendering each plant, I created abstract shapes of color and texture to suggest the different kinds of vegetation. Basically, I created a visual language. To add optic spice and interest, I accented the green shades with a jolting red (a mix of Alizarin Crimson and Vermilion). ☙ The overcast day contributed strongly to the flat look of the land. To counter this flatness and create visual interest, I relied heavily on my designed shapes and their relationship to the textural and color differences in the painting.

↞ Simplicity Has Force

SUSAN HARRISON-TUSTAIN

The effectiveness of *Psiche Abbandonata* is in the simplicity of the composition. The emphasis of light against shade allows the statue to emerge gradually from the luminous shadows. The almost translucent depth gives the feeling of mystery and creates the atmosphere of a serene and tranquil Italian museum. The gentle merging of shadows over the marble describes the form. The soft folds of fabric fall gracefully, giving an elegant demeanor emphasized by the texture of the rock—a powerful yet gentle and thought-provoking image. ☙ The strength of this composition is in the contrasts—light against dark, warm against cool and smooth marble against rough stone. With a limited palette of Indian Yellow, Alizarin Crimson and Thalo Blue, and with careful observation, I molded the form by juxtaposing these contrasting elements. I used my priming method to gently build up fine washes to create richness, depth and a true sense of presence.

The 7-Up sign had been painted on the side of an old country store, long since a victim of the interstate system. An ingenious homeowner salvaged the boards and applied them to the side of his house in the order that they came off his truck. The textures of the striated weathered wood and the slick brightness of the painted sign created a foil for the soft folds of the tar paper and the fluid motion of the wind sock. I developed the different types of texture by exploring the use of subtle shadows. I started with my shadows and built from there. Texture is created as much by shadows as by the texture of the material. The contrast between bright and subdued colors as well as the texture of the materials helped to produce the overall texture of this painting. I used Payne's Gray for the initial shadows and Dr. Ph. Martin's Hydrus watercolors for the bright colors. I prefer Lanaquarelle paper because it produces more vibrant colors.

—*Hosey Hutson*

depicting a variety of

manmade textures

7-UP RECYCLED Hosey Hutson, 16" x 26" (41cm x 66cm)

MUSEUM GUARDS Kathleen Hooks, 21" x 27" (53cm x 69cm)

⚡ Inspired by Stone Craftsmanship

KATHLEEN HOOKS

This museum in Philadelphia, Pennsylvania, was a perfect subject. As I stood beneath the "museum guards," I was inspired by the craftsmanship and detail of the stone masonry work, and the variety of textures available to convey. The reflections of the partially overcast day in the windows and the green copper sheathing added the contrast needed to the muted earth tones of the building. ⁘ I worked on each area individually until it was complete. The textures were achieved with various glazing, dry-brush and lifting techniques on top of wet-into-wet washes of Cobalt Blue, Indian Red, Cadmium Orange and Permanent Rose.

⇢ Light Rays Enhance Human Design Efforts

WILLIAM D. SCHLAEBITZ

During a visit to a French cathedral I was greeted by the striking visual image that appears in my painting. The sun rays passed across the vaulted ceiling and stained glass window highlighting the angel-covered pulpit and created this very dramatic scene. This was the basis for my painting to which I added the principles that I always strive for: emphasis, movement, pattern, balance and contrast. ⁘ I first painted the cathedral with traditional washes of Payne's Gray, Ochre and Ultramarine. Then, after the paint was dry, the light rays were created by using an abrasive eraser in directional strokes.

FRENCH CATHEDRAL William D. Schlaebitz, 31" x 23" (79cm x 58cm)

HIBISCUS AT THE CLOISTER James Hugh McCauley, 20" x 7.75" (51cm x 20cm)

◄◄ Rough Paper Can Work for Tight Subjects

JAMES HUGH McCAULEY

The contrast between the fleeting beauty of the hibiscus blossoms and the time-worn lamp at this entry to The Cloister at Sea Island, Georgia, prompted me to explore the juxtaposition of the solid and the subtle, both, in their own ways, ageless. ◄ I use Arches 300-lb. (638gsm) rough watercolor paper even for tightly rendered subjects. It accepts a wet-in-wet treatment—as evidenced in the cast shadow and the lamp glass—but also allows for the dry-brush glazing applied in the metal lamp housing. An invaluable color to me for aged metal is Burnt Sienna, used very dry. Specks of white were picked out of the dried surface with a razor knife.

►► Collect a Variety of Objects and Harmonize Them

DIANE JACKSON

Unusual combinations of objects, each with their own particular textures and patterns, have always been an irresistible challenge to me as a watercolorist. In *Songs & Symphonies* my objective was to blend the many contrasting textures, such as the rigid prismatic forms of cut glass, the flowing shapes of woven lace and the loose, open forms of daisies, all reflected in the brass pitcher and bowl. ◄ Ample preliminary sketching and thought went into this piece. I was constantly mindful of harmonizing the textures and forms of the objects, yet at the same time bringing out their individual characteristics.

SONGS & SYMPHONIES Diane Jackson, 27.5" x 20" (70cm x 51cm)

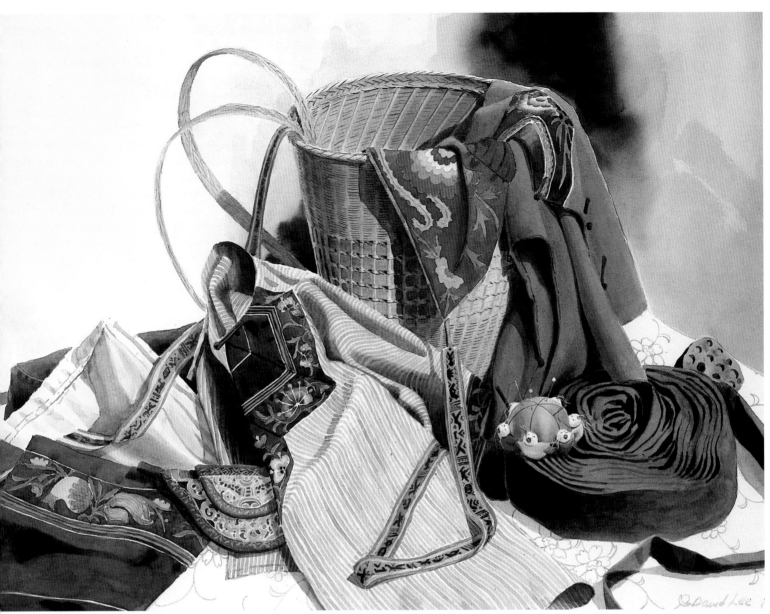

NEEDLEWORKS David Lee, 21" x 29" (53cm x 74cm)

♟ Adjust Brush Wetness for Various Textures

DAVID LEE

Although this is a realistic painting, I composed it as an abstract painting with various textures and shapes. While arranging these objects, I tried to interweave odd shapes with linear shapes to guide the viewer's eye through the entire painting. The simple and bold background provides a breathing space. ◦ৎ Contrast in textures, colors and value is my key for interesting composition. I used very wet brushes for smooth and shining surfaces such as silk, and drier brushes for the rough textures of the basket and lotus seed. An accurate drawing is a solid foundation for a realistic painting.

✦ An Exercise in Contrasts

CLAIRE SCHROEVEN VERBIEST

In order to energize the relatively simple concept of this painting, I decided to use a variety of contrasts: light against dark, cool against warm. Less perceptible but no less significant are the contrasts in textures. The background, a straightforward and arbitrary visual rendition of a wall and the space beyond it, is set against a middle ground that includes accurate renderings of the tactile qualities typical of familiar textures such as leather, fabric and metal. ◦ৎ The idea of contrasts was extended to the paints and paint application: transparent versus opaque and wet-into-wet versus drybrush. The accentuated darks are mixtures of Thalo Green, Alizarin Crimson, Cobalt Blue and Burnt Sienna.

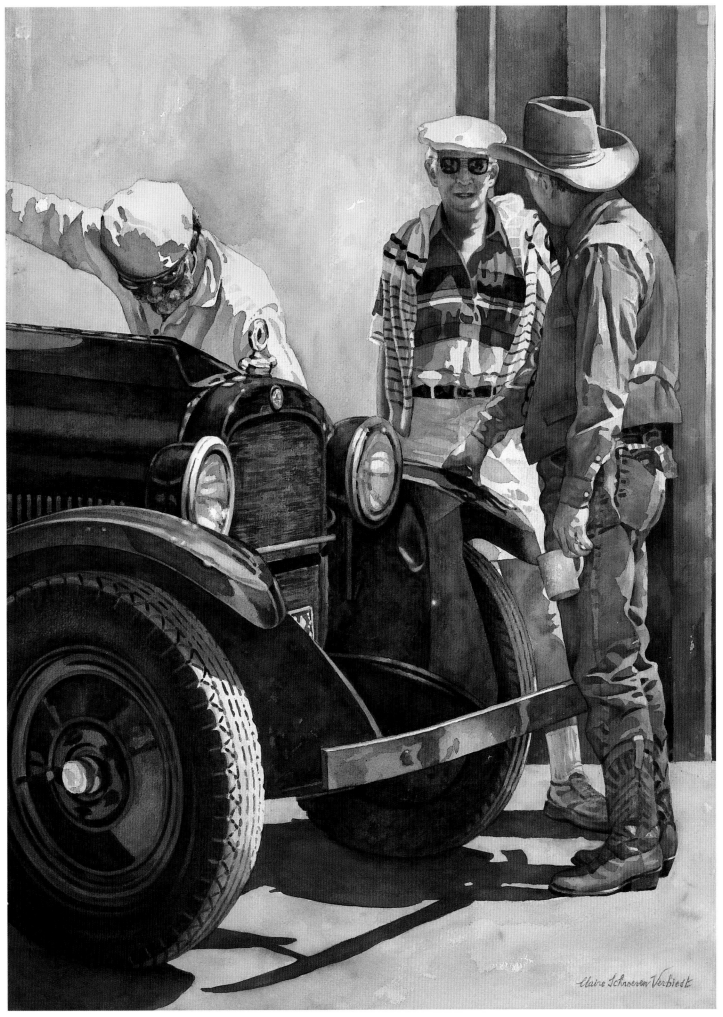

THREE MEN AND A BUGGY Claire Schroeven Verbiest, 30.25" x 22.75" (77cm x 58cm)

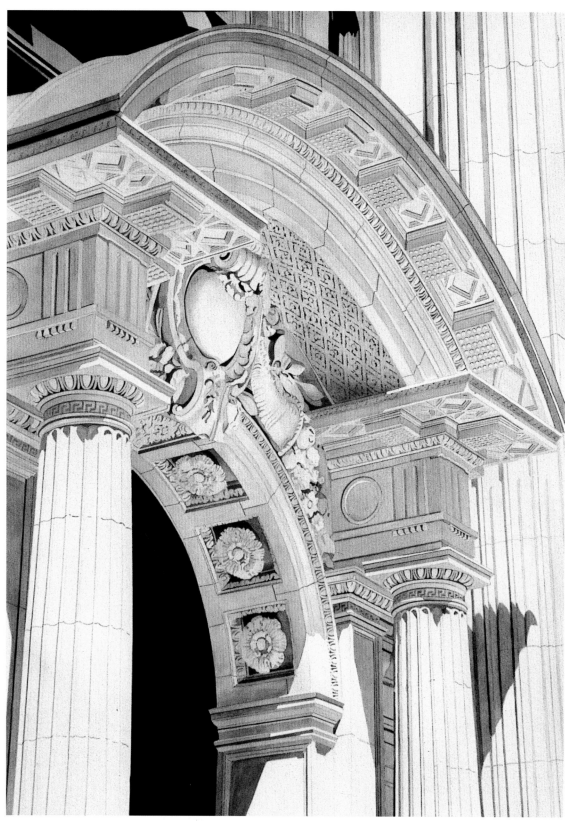

GRAND ENTRANCE Herb Rather, 30" x 22" (76cm x 56cm)

Use Indirect Light to Define the Textures in Shade

HERB RATHER

This richly ornamented entry is highly textured by the elaborately carved stone surfaces. Such subjects are favorites of mine. Although most of the carvings are in shade, the reflected light from below provides adequate illumination in the shaded areas. Many subtle color and value changes are produced by this indirect light, enriching the delineation of the textured surfaces. Carefully placed dark shadow areas provide the punch of stronger value changes needed to enliven the primarily mid-value painting. ✺ The primary color used is Winsor & Newton Naples Yellow. I often use a light wash of this soft yellow for stonework. It does not mix well and contaminates very easily, so clean water and brushes are required. The entire painting was executed on dry Arches rough paper, without masking. Winsor Blue (slightly modified with black), Raw Sienna, Warm Sepia and Sepia Umber are used in the shaded areas.

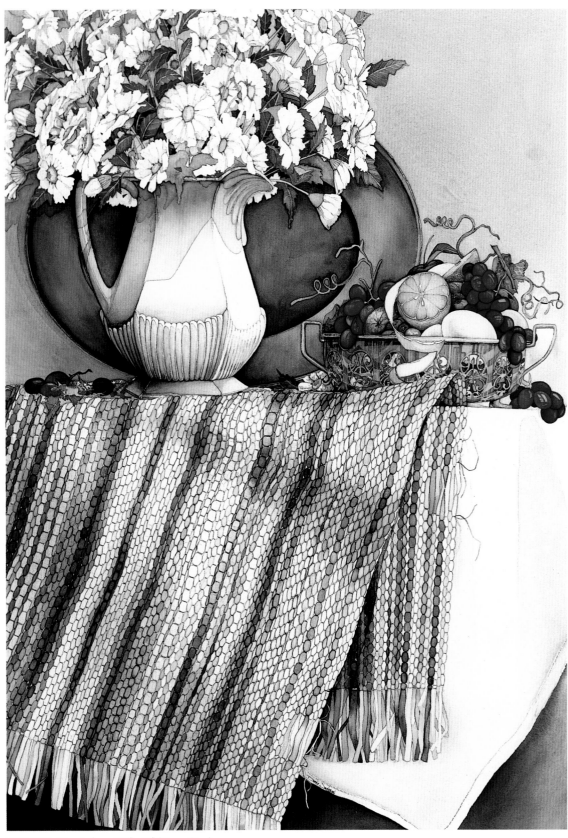

MOON GLOW Diane Jackson, 28.5" x 21" (72cm x 53cm)

Combine Textures, Forms and Colors

DIANE JACKSON

Moon Glow began with my fascination with the beauty and wonderful forms and shadows found in an old ironstone pitcher. The idea for the painting quickly progressed with the discovery of a worn, somewhat tattered scrap rug. The wide range of color in the rug seems to complement and softly contrast the warm, uncomplicated surface textures of the pitcher. The warm glow and reflective qualities of the brass bowl filled with colorful fruit were then put in place for the purpose of unifying the various textures, forms and colors, and completing an effective composition. ❧ I combine broad areas of subtle washes to establish the smooth textures in the painting, followed by smaller, more controlled and confined areas of wash for the shadows and more detailed subjects. Final dry-brush details were added.

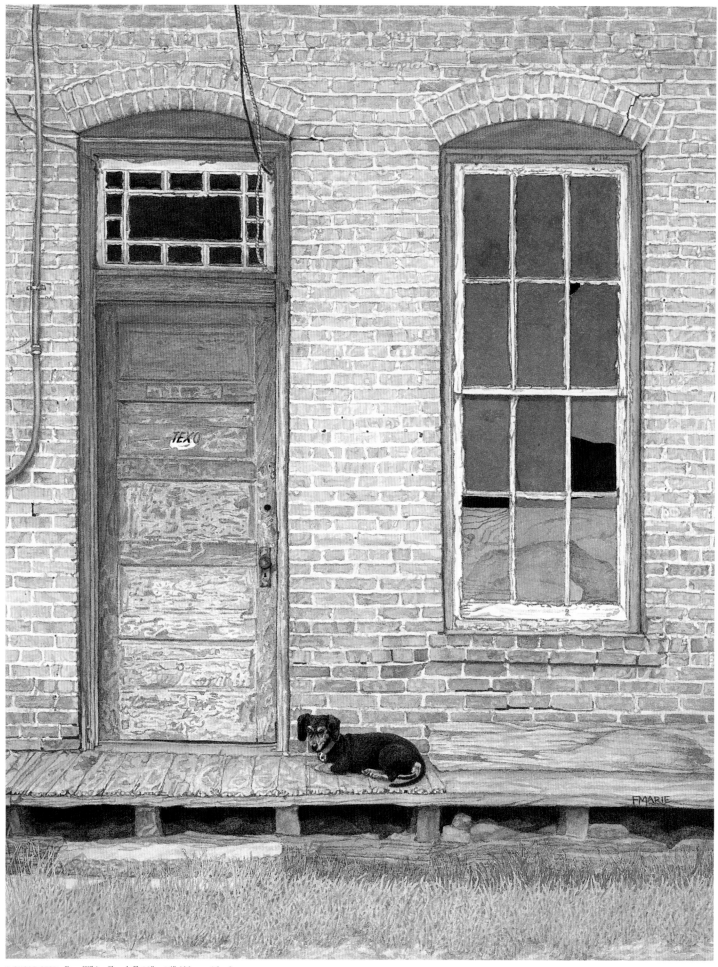

A SHORT STOP Fran White Shurtleff, 18" x 14" (46cm x 36cm)

WEBER'S James Toogood, 13.75" x 21" (35cm x 53cm)

✤ Don't Overlook Common Manmade Textures

JAMES TOOGOOD

My work is about contemporary life where natural and manmade textures meet. The strength of this painting comes from manmade textures. We can see the smooth texture of the glass, plastic and high-gloss paint. Even in the parking lot the smoothness seems to reflect some of the building, as if a fresh coat of sealer has been recently applied. Metal, asphalt and other manmade materials may not be traditional sources of beauty, but they offer us rich textures that speak vividly about the world around us. ◦⟩ Understanding the different characteristics of your paint is key to communicating various textures. Transparency, opacity, tinting strength and staining are but a few of these characteristics. Some textures can be depicted by building up a number of thin washes, as in the plastic awning in *Weber's*. Other times dropping a slightly thicker paint into a damp wash and letting it disperse helps create the look of rust, as on the metal frame of that same awning.

⟲ No Tricks for Wonderful Textures of Old Buildings

FRAN WHITE SHURTLEFF

Old buildings have such wonderful textures. The bricks are uneven; the mortar has been patched; the paint is blistered or peeling to expose old colors beneath. Sometimes the wood is weathered to reveal variations of subtle color. ◦⟩ The technique I use to paint these old buildings is simple. Large areas are covered with washes; over these washes I layer color, using mostly dry-brush strokes to finish. I rarely use masking materials, preferring to paint negatively around the light areas. I've learned some shortcuts to create texture, but love to achieve my texture goals using only paint, water and brush. I use a rather limited palette, electing to mix colors myself rather than using them straight from the tube.

CHORUS LINE Fran White Shurtleff, 21" x 17" (53cm x 43cm)

Create a Mood With Reflections

JEAN SMITH

I have always been fascinated by views created through reflections. Sometimes they are clear and sharp; other times they are hazy due to glass distortions; but always, they provide a new and exciting perspective. The sunlight dancing through the shadow on the bricks, and the bit of sky and trees reflected by the church window provide the texture in this painting. ⁂ The effect of the weather-worn bricks was created by rubbing wax on some areas to keep paint off before I applied washes. I used very intense layers of color (a mixture of Bright Red, Burnt Sienna, Winsor Red and Mauve) on the bricks to provide contrast.

Old Subjects "Wear" Textures Well

FRAN WHITE SHURTLEFF

I was attracted to the used hydrants lying beside the fire station because of the countless small abstract shapes and colors that together created the visual texture on their surfaces. Many of my subjects are old, but it's not a feeling of nostalgia that draws my interest to them; it's the wonderful textures they tend to wear. When I finish a painting, I usually put it on my easel for several days, so that I can see it with "fresh" eyes as I come into the room. This was supposed to be a horizontal painting, but, as it sat on the easel vertically, it seemed to say, "Yes!" and the hydrants became a chorus line standing behind the footlights for a final bow. ⁂ I've tried all kinds of paper for my transparent watercolors, but I keep coming back to Arches 300-lb. (638gsm) hot-press. The colors seem crisp and clean on the smooth surface.

REFLECTIONS IV Jean Smith, 18.5" x 6" (47cm x 15cm)

SUNDAY BRUNCH Peter Hanks, 12.5" x 17" (32cm x 43cm)

❧ Accentuate Dissimilar Textures by Juxtaposing Them

PETER HANKS

Arranging a still life that has a stimulating mix of dissimilar textures can be a real feast for the eyes. The texture of the chrysanthemums seems much softer when viewed next to the sharp, reflective surface of the vase; the soft qualities of the tablecloth and dappled shadow contrast and enhance the hard, smooth textures of the mug and plate. ❧ All the objects in this still life, including the tablecloth, were painted using a layered glazing technique. To obtain the soft, cottony feel of the cloth, I first painted the shadow, applying three separate glazes of Cobalt Blue, Winsor Red and Winsor Yellow, allowing each glaze to dry thoroughly before proceeding to the next. Thus, the finished shadow, although having an overall gray appearance, actually has numerous temperature and value variations that bring it to life. Then I softened the edges of the shadow and added the checkerboard pattern, following the contours of the folds.

↣ Take a Good Look at Your Subject

SUSAN HARRISON-TUSTAIN

I love the story this painting tells. While taking a drink at a fountain in a square in old Venice, my "little friend" managed to drench himself with water. The perturbed but appealing expression on his sweet face, thumb in mouth, asks how he's going to explain this one to "Mamma." In capturing this magical moment I was challenged with a full range of textures, from the smooth, hard relief work on the fountain and the glassy surface of the wet cobblestones to the smooth softness of this little lad's skin. ❧ The secret behind describing texture is simple observation of the way light reflects off the surface. Notice how the little lad's legs, the stream of water and the fruit box are reflected in the wet cobbles. Take a good, long look at your subject and simply paint what you see!

ADESSO CHI LA SENTE LA MAMMA Susan Harrison-Tustain, 19" x 13" (48cm x 33cm)

Dona Abbott
2855 Iliff St., Boulder, CO 80303
members.aol.com/dabbott303, dabbott303@aol.com
p. 104 IN THE REALM OF KINGS © Dona Abbott

Derwin Abston
12116 Wedgeway Place, Fairfax, VA 22033
p. 17 PENSION BUILDING © Derwin Abston, collection of
the artist

Cindy Agan
1201 Belmont Ave., S. Bend, IN 46615
(219) 233-7950
p. 82 WHEN I GROW UP... © Cindy Agan, private collection

Diane Allen
140 Ferry St., S. Hadley, MA 01075
p. 61 McKINSTRY TRACTOR © Diane Allen, collection of
Jack Martin

Connie "Zekas" Bailey, WCWS
3535 Linda Vista Dr. #80, San Marcos, CA 92069
p. 56 HELLO BLONDIE © Connie "Zekas" Bailey, private collection

Ruth L. Beeve
5595 Banff Court, Concord, CA 94521
p. 16 RIVER OF LIGHT © Ruth L. Beeve, collection of the artist

Judi Betts, AWS
P.O. Box 3676, Baton Rouge, LA 70821-3676
p. 105 BUENOS DIAS © Judi Betts, collection of Diana and Jack
Burton, Granbury, TX

Carol Black
2084 Roberts Place, Escondido, CA 92029
p. 25 WATER BALLOONS II © Carol Black, collection of the artist

Susan K. Black
600 Lilley Yeager Loop N., Cleveland, TX 77327
p. 84 ON THE ROCK © Susan K. Black, collection of Hank and
Janeen Fisk

Denise Boie
RRoute 1, Box 71, Akeley, MN 56433
deniseboie@hotmail.com
p. 81 THE VISITOR © Denise Boie, collection of Leslie Meyer

Helen Bond
1121 N. Oxford St., St. Paul, MN 55103
p. 110 GENESIS © Helen Bond

Anne Boucher
66 Fuller Rd., Centerville, MA 02632
(508) 775-4214
p. 31 TRAILING SILVER © Anne Boucher, collection of Cahoon
Museum of American Art, Cotuit, MA

Pauline Boudreau
3270 Delorme, Sherbrooke, Quebec
Canada J1K 2Z5
artpb@videotron.ca
p. 38 UN INSTANT D'ÉTERNITÉ © Pauline Boudreau, private
collection

Gail Bracegirdle
875 Farley Rd., Bensalem, PA 19020-4021
p. 52 OCTOBER © Gail Bracegirdle

Jane Carson Britt
124 Beechwood Dr., Franklin, VA 23851
p. 116 ELTON FROG II © Jane Carson Britt, collection of Mr. and
Mrs. Austin T. Darden

Gerald Brommer
11252 Valley Spring Lane, Studio City, CA 91602
p. 60 CAPE COD LIGHTHOUSE © Gerald Brommer, private collec-
tion courtesy New Masters Gallery, Carmel, CA

Joan A. Burr
P.O. Box 286, Joseph City, AZ 86032
p. 118 RED SERIES #5 © Joan A. Burr

Mary Anne Lipousky Butikas
417 Moses Ave., Westville, IL 61883
(217) 267-7791
p. 1 CLASSIC FORD #2 © Mary Anne Lipousky Butikas

Mary Gregg Byrne
P.O. Box 4190, Bellingham, WA 98227-4190
mgbyrne@cio.net
p. 20 HELEN'S CRYSTAL COCKTAILS © Mary Gregg Byrne

Amy Callaway
248 Quincy Rd., Kirbyville, MO 65679
members.tripod.com/~Scott_Callaway/Amys_Art/,
callaway@tri-lakes.net
p. 77 FELINE FASCINATION © Amy Callaway

Sally Cays
101 W. Robert Place, Sequim, WA 98382
p. 32 SATURDAY MARKET © Sally Cays, collection of
Cedarbrook Herb Farm, Sequim, WA
p. 115 TRIBUTE © Sally Cays, collection of Mr. and Mrs.
David Ordell, Mercer Island, WA
p. 45 TRILOGY © Sally Cays, collection of Mr. and Mrs.
Blayne Rollman, Bremerton, WA

Julie Christiansen-Dull
31851 Via de Linda, San Juan Capistrano, CA 92675
p. 113 SIOUX TRADITION © Julie Christiansen-Dull

Judi Coffey, NWS
11807 Catrose Lane, Cypress, TX 77429
p. 46 39¢ A POUND © Judi Coffey, collection of the artist

Mark A. Collins
1304 Creekside Dr., Charlottesville, VA 22902
p. 49 GOLDEN MOMENT © Mark A. Collins
p. 34 LEGACY © Mark A. Collins
p. 96 RAINY DAY IN SAANEN © Mark A. Collins
p. 53 RED DOZEN © Mark A. Collins

Susan J. Connor
9171 Turtle Point Rd., Killen, AL 35645
(256) 757-4298
lconnor@getaway.net
p. 54 TIDE POOL © Susan J. Connor, private collection

George E. Cook
Higgins Mobile Park, 27 Calvin Rd., Plainville, MA 02762
(508) 695-6360
p. 28 AUTUMN SYMPHONY © George E. Cook

Laurel Covington-Vogl
333 Northeast Circle, Durango, CO 81301
p. 18 PACKARD IN THE PARK © Laurel Covington-Vogl

Brenda Cuthbertson
99 Morrison Ave., Beaverton, Ontario
Canada LOK IAO
p. 89 DREAM COME TRUE © Brenda Cuthbertson

Dean Davis, NWS
207 La Donna, Evansville, IN 47711
p. 117 SAN ANDREAS ZIPPER © Dean Davis

Gayle Denington-Anderson
661 S. Ridge E., Geneva, OH 44041
p. 111 HOT SUMMER NIGHT © Gayle Denington-Anderson, collec-
tion of the artist; appeared at Glass Growers Gallery, Erie, PA

Cynthia Van Horne Ehrlich
74 Oak Hill Rd., Westford, MA 01886
(978) 692-3516
p. 58 RED WHITE RETURNING © Cynthia Van Horne Ehrlich,
collection of Greg and Carol Duff, photographed by Gary Pihl

Nancy Ann Fazzone-Voss
111 Eastside Dr., Ballston Lake, NY 12019-2117
p. 47 SNACKS © Nancy Ann Fazzone-Voss

Joseph Fettingis, NWS
Lakeview Studio, 625 Lakeview Dr., Logansport, IN 46947
p. 79 LADY IN RED © Joseph Fettingis

Fran Fixaris
4303 S. Atlantic Ave., New Smyrna Beach, FL 32169
p. 40 VINE RIPE II © Fran Fixaris

Tom Fong, WW
1903 S. Meridian Ave., Alhambra, CA 91803
(626) 282-3790
fongfam@juno.com
p. 68 PACIFIC COAST SEASCAPE © Tom Fong

Donna Francis

5155 Eldon Dr. S., Colorado Springs, CO 80916

(719) 390-7478

p. 69 MACAW! © Donna Francis

Ann Gaechter, NWS

P.O. Box 285, Woody Creek, CO 81656

anngaechter@hotmail.com

p. 98 SUN DRENCHED © Ann Gaechter

Allen Faxon Gardiner

62 High Hill Rd., Tuxedo, NY 10987

(914) 351-5234

p. 106 AZALEAS © Allen Faxon Gardiner

Gerry Grout

14241 W. Greentree Dr., Litchfield Park, AZ 85340

p. 108 SPIRITUAL PLACE OF STONE © Gerry Grout

Linda S. Gunn

5209 Hanbury St., Long Beach, CA 90808

p. 102 STEEPHILL, LINCOLNSHIRE © Linda S. Gunn

Elaine Hahn, AWS, NWS

8823 Lake Hill Dr., Lorton, VA 22079

p. 12 REFLECTIONS © Elaine Hahn, collection of the Coconut
Grove Association, Coconut Grove, FL

p. 51 STARFISH BOUNTY © Elaine Hahn, collection of the artist

Diane E. Halley, NWS

6631 Osceola Court, Arvada, CO 80003

p. 75 PORTRAIT OF HERMAN AND ANNA © Diane E. Halley

p. 74 PORTRAIT OF JOHN COKER—DURANGO TO SILVERTON NARROW
GAUGE © Diane E. Halley

Peter Hanks

26171 Bruffs Island Rd., Easton, MD 21601

p. 85 BLUE CRAB © Peter Hanks; prints available, edition 950

p. 136 SUNDAY BRUNCH © Peter Hanks; prints available,
edition 950

Mary Jo Harding, NWS, SWS

216 W. Meadow Lane, Wimberley, TX 78676

p. 5 SUNSET AT SAN XAVIER © Mary Jo Harding

Ann Hardy

900 John McCain, Colleyville, TX 76034-6133

p. 66 ASTORIA © Ann Hardy, collection of Gene and Gloria
Talley, Southlake, TX

Susan Harrison-Tustain

85 Castles Rd., Oropi, RD 3, Tauranga, New Zealand

harrison-tustain@clear.net.nz

p. 137 ADESSO CHI LA SENTE LA MAMMA © Susan Harrison-Tustain,
private collection; available as a limited edition print

p. 120 PSICHE ABBANDONATA © Susan Harrison-Tustain,
private collection

Mary Henderson

Mary Henderson Watercolor Studio, 6447 Park Blvd., Suite 8,
Pinellas Park, FL 33781

(727) 546-6488

www.watercolorartists.com

p. 35 MANY MONARCHS © Mary Henderson

Gwen Talbot Hodges

522 Applespice Dr., Shreveport, LA 71115

p. 103 FACETS OF FULFILLMENT © Gwen Talbot Hodges, collection
of David and Susan Winkler

p. 97 HOPE SHINING THROUGH © Gwen Talbot Hodges, collection
of Mr. and Mrs. Fred Wagner

p. 95 LIGHT BREAKING THROUGH © Gwen Talbot Hodges, collec-
tion of Mrs. Vassar Mills

Kathleen Hooks

239 Clearview Rd., Pasco, WA 99301

(509) 547-4565

p. 124 MUSEUM GUARDS © Kathleen Hooks

Hosey Hutson

3146 Renfro Rd., Birmingham, AL 35216

(205) 979-7187

p. 122 7-UP RECYCLED © Hosey Hutson, collection of the artist

Diane Jackson

P.O. Box 211, Montross, VA 22520

(804) 493-0222 (studio/gallery)

p. 131 MOON GLOW © Diane Jackson

p. 127 SONGS & SYMPHONIES © Diane Jackson

Judy Jones

1360 Bond Lane, Eugene, OR 97401

jujoarts@aol.com

p. 94 BACK FENCE LIAISON © Judy Jones, at O-Two Gallery,
Maebashi City, Japan

Pamela Kazal

6150 S. Mesquite Trail, Tucson, AZ 85747

(520) 647-7294

p. 42 CHOLLA RADIANCE © Pamela Kazal

Elizabeth Kincaid

3660 Crestline Way, Soquel, CA 95073

p. 50 SUNSET AT PEGGY'S COVE © Elizabeth Kincaid, collection of
Bob and Terri Hamilton

Mary T. Kingston

100 Hepburn Rd., Clifton, NJ 07012

(973) 777-5857

p. 41 STONES AND POPPIES © Reproduced by permission of
The Gallery Collection ® Prudent Publishing Company

Karen Knutson

8621 Coachman's Lane, Eden Prairie, MN 55347

p. 63 HEAVEN TO EARTH © Karen Knutson, collection of Bruce
and Kathy Riemer

Frank LaLumia

P.O. Box 3237, Santa Fe, NM 87501-3237

(505) 455-3133

p. 91 DESERT TORTOISE © Frank LaLumia, courtesy
Columbine Gallery, Loveland, CO

Donna Lamb

Church Street Art Gallery

122 N. Church St., Nacogdoches, TX 75961

(409) 560-0050

p. 88 BOOTS © Donna Lamb

p. 76 JODY'S CAT © Donna Lamb

Maria Josefina Lansangan S., DDS, FAGD

1307 W. Stewart Dr., Orange, CA 92868

(714) 771-2900

p. 71 CHRYSANTHEMUM © Maria Josefina Lansangan S.,
collection of Mr. and Mrs. Joe Blanche

p. 70 WHITE LOTUS © Maria Josefina Lansangan S., private
collection

David Lee

186 Hickory St., Westwood, NJ 07675

p. 128 NEEDLEWORKS © David Lee

Victor Martinez

525 Sierra Place, El Segundo, CA 90245

www.victormartinez.com

p. 80 COLLAGUA—PERU © Victor Martinez, private collection,
Escondido, CA

James Hugh McCauley

14701 Capri Rd., Orlando, FL 32832

p. 126 HIBISCUS AT THE CLOISTER © James Hugh McCauley,
Left Bank Art Gallery, St. Simons Island, GA

p. 44 HOUSE ON THE MARSH © James Hugh McCauley, collection
of the artist

Paul W. McCormack

P.O. Box 537, Glenham, NY 12527

p. 83 ALTRUISTIC PATTERN © Paul W. McCormack, collection of
Leslie Iffy

p. 8 HOPE © Paul W. McCormack, courtesy Portraits Inc.,
New York, New York

p. 114 PAMELIA © Paul W. McCormack, collection of Mr. and
Mrs. David Weber

Marlies Merk Najaka

241 Central Park W., New York, NY 10024

(212) 580-0058

watercolorart.com

p. 27 LOST AND FOUND © Marlies Merk Najaka; available as a
limited edition giclée print

Mary Ann Neilson

50 Coleytown Rd., Westport, CT 06880

(203) 454-3408

p. 36 PEONY, CORAL CHARM © Mary Ann Neilson

Barbara Oline
34 Crepe Myrtle Place, Little Rock, AR 72009
p. 65 EVIDENCE OF TIME © Barbara Oline, collection of the artist

Bambi Papais
P.O. Box 587, Murphys, CA 95247
p. 2 WILDFLOWER TAPESTRY © Bambi Papais, collection of
Robert Gurney

Monika A. Pate
2900 Ridgetop Rd., Ames, IA 50014
p. 92 CABBAGE SUNLIGHT © Monika A. Pate
p. 99 LEMON AND LACE © Monika A. Pate

Beth Patterson
21 Jensen Ave., Chelmsford, MA 01824-2247
p. 10 39¢ A LB. © Beth Patterson

Carolyn H. Pedersen
119 Birch Lane, New City, NY 10956
p. 119 FEBRUARY © Carolyn H. Pedersen, collection of Dr. and
Mrs. James W. Flax, New City, NY

Ann Pember
Water Edge Studio, 14 Water Edge Rd., Keeseville, NY 12944
p. 23 TURBULENT WATERS © Ann Pember

George D. Powell
316 Central Ave., Alameda, CA 94501
(510) 522-3904
p. 21 TOO WET TO FLY © George D. Powell, collection of the
artist

Sharon Rajnus
30485 Transformer Rd., Malin, OR 97632
(541) 723-4371
p. 19 FLAVOR OF ALASKA © Sharon Rajnus
p. 24 GLACIER FLYING—OS2U KINGFISHER © Sharon Rajnus

Herb Rather, AWS, NWS
Route 1, Box 89, Lampasas, TX 76550
(512) 556-8161
p. 130 GRAND ENTRANCE © Herb Rather
p. 62 SWITCH © Herb Rather

Robert Reynolds
958 Skyline Dr., San Luis Obispo, CA 93405
p. 121 TIDE LAND TAPESTRY © Robert Reynolds

Joan I. Roche
1149 McDonald Rd., Fallbrook, CA 92028
p. 48 EUCALYPTUS IV © Joan I. Roche, collection of the artist

Barbara Rubin
4907 Arthur St., Hollywood, FL 33021
p. 30 STATUE I © Barbara Rubin

Garland Rush
15700 Arnold Dr., Sonoma, CA 95476
p. 26 BIG TOW © Garland Rush
p. 15 TRICLOPS © Garland Rush

John T. Salminen, AWS, DF, NWS
6021 Arnold Rd., Duluth, MN 55803
p. 101 BRIGHTON BEACH MARKET, NYC © John T. Salminen
p. 100 SEVENTH AVENUE VENDOR, NYC © John T. Salminen
p. 107 WABASH STREET, CHICAGO © John T. Salminen

William D. Schlaebitz, AIA
6939 Sumner St., Lincoln, NE 68506
p. 125 FRENCH CATHEDRAL © William D. Schlaebitz, personal
collection

Concetta C. Scott
1111 Dead Run Dr., McLean, VA 22101
(703) 356-5053
pbscotts@ami.net
p. 43 INDIAN CORN—LIFE CYCLES V © Concetta C. Scott; The Art
League 1998 December show, Torpedo Factory, Alexandria, VA;
McLean Art Club 1997 May show, Emerson Gallery, McLean, VA;
1997 American Horticultural Society two-person show,
Mt. Vernon, VA

Fran White Shurtleff
2208 Post Oak Court, Corinth, TX 76205
p. 134 CHORUS LINE © Fran White Shurtleff
p. 132 A SHORT STOP © Fran White Shurtleff

Jean Smith
10903 Innisbrooke Lane, Fishers, IN 46038
p. 90 OFF TO THE TEE © Jean Smith, collection of the artist
p. 135 REFLECTIONS IV © Jean Smith, collection of Hamilton
County Libraries

Siv Spurgeon
600 N. Swarthmore Ave., Swarthmore, PA 19081
p. 14 SHADES TO GO © Siv Spurgeon, collection of the artist

Ardith Starostka
31 Clear Lake, Columbus, NE 68601
rstrakt@megavision.com
p. 78 HALEY AND COMPANY © Ardith Starostka

Nancy R. Stirm
1369 Halibut St., Foster City, CA 94404
p. 37 CACTUS II © Nancy R. Stirm, private collection; chosen
for the Biennial Statewide Watercolor Competition and Exhibi-
tion 1994 show
p. 39 ROCK SOLID © Nancy R. Stirm, collection of the artist; re-
ceived Most Popular award in SWA's 45th Annual Show, San
Francisco, CA; chosen for the Biennial Statewide Watercolor
Competition and Exhibition 1996 show at the Triton Museum
of Art, Santa Clara, CA

James Toogood, AWS
920 Park Dr., Cherry Hill, NJ 08002
p. 29 ROCKY COAST, SOUTH SHORE—BERMUDA © 1999 James Too-
good, collection of Richard Thompson, Shelly Bay, Bermuda
p. 133 WEBER'S © 1999 James Toogood, collection of Daniel
Cohen and Leah Keith, New York, NY

Claire Schroeven Verbiest
3126 Brightwood Court, San Jose, CA 95148
p. 129 THREE MEN AND A BUGGY © Claire Schroeven Verbiest;
available for purchase

Donna L. Weida
Lakeview Studio, 625 Lakeview Dr.
Logansport, IN 46947-2202
(219) 722-5341
p. 87 CHRISTIAN © Donna L. Weida

Suzanne Welch
1790 Willow St., San Jose, CA 95125
p. 112 GOLDEN GATE BRIDGE II © Suzanne Welch, collection of
Darin and Kristine Delagnes

Gail M. Wheaton
9346 E. Hidden Green Dr., Scottsdale, AZ 85262
p. 22 CHEV © Gail M. Wheaton

Suzanna Reese Winton
Route 2, Box 454, Tallahassee, FL 32311
(850) 997-7477
p. 72 THE HAITIAN HAT MAN © Suzanna Reese Winton, collection
of the artist
p. 86 THE LADY FROM HAITI © Suzanna Reese Winton, collection
of Fred and Gloria Nuwsbickel

Donna Jill Witty
444 N. Hill St., Woodstock, IL 60098
p. 59 HARBOR GEMS © Donna Jill Witty, collection of the artist
p. 64 OLD WORLD WISCONSIN: HARVEST ON THE FARM © Donna Jill
Witty, private collection

Dolores Ann Ziegler
41B Molly Pitcher Blvd., Whiting, NJ 08759
(732) 849-9110
p. 57 HOLIDAY WINDOWS © Dolores Ann Ziegler; won award in
Baltimore Watercolor Show; accepted in San Diego 1998
Watercolor Show

A

Abrasive eraser, 124

Acrylic

mixing watercolor and, 56

watercolor and, 54, 68, 106, 111

with watercolor and charcoal, 109

with watercolor and gouache, 65

with watercolor, ink and watercolor pencil, 66

Acrylic matte medium, 61, 63

Animals, 21, 35, 56, 68, 76-77, 85, 88-89, 91, 104-105, 132

Antiquity effect, 70

B

Blotting, 67

Board

acrylic, 55

bristol, regular surface, 107

Crescent illustration, 111

Masonite, 80

Brushes, 23, 28, 56, 70, 72, 75-76, 80, 82, 88-89, 96, 102, 113, 116

C

Cast shadows, 21

Charcoal, with watercolor and acrylic, 109

Chrome, 14-15, 18, 26

Collage, 46, 63, 84

Colors

complementary, 18, 41-42, 107-108

cool, 37, 79, 107

diffusing, 52

dominant, 58

intensity at dusk, 31

jewel-like, 58

lifting, 23, 25, 32, 45, 80, 116, 124

light and contrasts in, 39

for mysticism, 113

optical mixing, 28

primary, 68, 96

reflected, 86

saturated, 42

texture and, 58, 131

transparent, 35

in transparent shadows, 27

underlying, 86, 96

underpainting washes of, 30

warm, 79

Contrasts

complements, 41

cool against warm, 121, 128

dark foreground-light background, 101

light against dark, 113, 121, 128

light and color, 39

light foreground-dark background, 101

in mediums, 111

porous flora vs. velvety fauna, 35

smooth against rough, 121

soft fur against rough surroundings, 76

textural, 20, 49, 52, 94, 126

transparent vs. opaque, 128

variety of, 128

void vs. mass, 111

wet-into-wet vs. drybrush, 128

Crinkled-paper technique, 52

Cut-out stamps, 46

D

Direct painting, 94

Dropping in paint, 94

Drybrushing, 19, 23, 26, 39, 42, 50, 75, 82, 89, 94, 104, 124, 126, 128, 131

F

Feathering, 82

Floating color, 44, 107

Flowers, 34-36, 38, 41-42, 45, 47, 70-71, 94-99, 106, 136

Frisket, 20, 50. *See also* Liquid masking; Masking fluid

G

Gesso

finishes, 23, 56, 80

mixed with watercolor, 41

watercolor and, 81-82

with watercolor, gouache and ink, 119

Glass, 20, 102, 126, 133

Glazing, 25, 28, 32, 41-42, 45, 48, 82, 93-94, 96, 108, 124

Gouache, 61

designer's, 37

fluorescent, 94, 96

on hot-press paper, 116

opaque, 46

watercolor and, 77, 88, 95, 97, 117

watercolors mixed with, 56

white, 76, 88

with watercolor and acrylic, 65

with watercolor and ink, 70-71

with watercolor, gesso and ink, 119

Grays, mixing complements for, 18

Gum arabic, 80

H

Halftones, 82

Highlights, 20, 32, 52, 80

Horizontal pattern, 68

I

Ice, 19, 24

Imaginative setting, 116

Impasto method, modified, 98

Ink

mixing with watercolors, 56

with watercolor, acrylic and watercolor pencil, 66

with watercolor and gouache, 70-71

with watercolor, gesso and gouache, 119

L

Lace, 45, 98, 126

Lifting color, 23, 25, 32, 45, 80, 116, 124

Light, 36, 39, 42, 48-49, 64, 76, 82, 93-94, 96, 98, 101-102, 104, 121, 124, 130, 135

Liquid masking, 26, 52, 112. *See also* Frisket; Masking; Masking fluid

M

Masking, 116

Masking fluid, 37, 39, 48, 82, 94, 96, 102. *See also* Frisket; Liquid masking

Maskoid, 58, 64

Mixed media, 46, 57, 60

Modified impasto method, 98

Monochromatic

background, 63

image, 36

subjects, 30

underpainting, 32

N

Needle, flow-through, 119

Negative painting, 119

No-brush technique, 111

P

Paint characteristics, 133

Paintings

ADESSO CHI LA SENTE LA MAMMA, 137

ALTRUISTIC PATTERN, 83

ASTORIA, 66-67

AUTUMN SYMPHONY, 28

AZALEAS, 106

BACK FENCE LIAISON, 94

BIG TOW, 26

BLUE CRAB, 85

BOOTS, 88

BRIGHTON BEACH MARKET, NYC, 101

BUENOS DIAS, 105

CABBAGE SUNLIGHT, 92-93

CACTUS II, 37

CAPE COD LIGHTHOUSE, 60

CHEV, 22

CHOLLA RADIANCE, 42

CHORUS LINE, 134

CHRISTIAN, 87

CHRYSANTHEMUM, 71

CLASSIC FORD #2, 1

COLLAGUA—PERU, 80

DESERT TORTOISE, 91

DREAM COME TRUE, 89

ELTON FROG II, 116

EUCALYPTUS IV, 48

EVIDENCE OF TIME, 65

FACETS OF FULFILLMENT, 103

FEBRUARY, 119

FELINE FASCINATION, 77

FLAVOR OF ALASKA, 19

FRENCH CATHEDRAL, 125

GENESIS, 110

GLACIER FLYING—OS2U KINGFISHER, 24

GOLDEN GATE BRIDGE II, 112

GOLDEN MOMENT, 49

GRAND ENTRANCE, 130

HAITIAN HAT MAN, THE, 72-73

HALEY AND COMPANY, 78

HARBOR GEMS, 59

HEAVEN TO EARTH, 63

HELEN'S CRYSTAL COCKTAILS, 20

HELLO BLONDIE, 56

HIBISCUS AT THE CLOISTER, 126

HOLIDAY WINDOWS, 57

HOPE, 8

HOPE SHINING THROUGH, 97

HOT SUMMER NIGHT, 111

HOUSE ON THE MARSH, 44

INDIAN CORN—LIFE CYCLES V, 43

JODY'S CAT, 76

LADY FROM HAITI, THE, 86

LADY IN RED, 79

LEGACY, 34

LEMON AND LACE, 99

LIGHT BREAKING THROUGH, 95

LOST AND FOUND, 27

MACAW!, 69

MANY MONARCHS, 35

McKINSTRY TRACTOR, 61

MOON GLOW, 131

MUSEUM GUARDS, 124

NEEDLEWORKS, 128

OCTOBER, 52

OFF TO THE TEE, 90

OLD WORLD WISCONSIN: HARVEST ON THE FARM, 64

PACIFIC COAST SEASCAPE, 68

PACKARD IN THE PARK, 18

PAMELIA, 114

PENSION BUILDING, 17

PEONY, CORAL CHARM, 36

PORTRAIT OF HERMAN AND ANNA, 75

PORTRAIT OF JOHN COKER—DURANGO TO SILVERTON

NARROW GAUGE, 74

PSICHE ABBANDONATA, 120

RAINY DAY IN SAANEN, 96

REALM OF KINGS, IN THE, 104-105

RED DOZEN, 53

RED SERIES #5, 118

RED WHITE RETURNING, 58

REFLECTIONS, 12-13

REFLECTIONS IV, 135

RIVER OF LIGHT, 16

ROCK, ON THE, 84

ROCK SOLID, 39

ROCKY COAST, SOUTH SHORE—BERMUDA, 29

SAN ANDREAS ZIPPER, 117

SATURDAY MARKET, 32-33

SEVENTH AVENUE VENDOR, NYC, 100

7-UP RECYCLED, 122-123

SHADES TO GO, 14

SHORT STOP, A, 132

SIOUX TRADITION, 113

SNACKS, 47

SONGS & SYMPHONIES, 127

SPIRITUAL PLACE OF STONE, 108-109

STARFISH BOUNTY, 51

STATUE I, 30

STEEPHILL, LINCOLNSHIRE, 102

STONES AND POPPIES, 41

SUN DRENCHED, 98

SUNDAY BRUNCH, 136

SUNSET AT PEGGY'S COVE, 50

SUNSET AT SAN XAVIER, 5

SWITCH, 62

39¢ A LB., 10-11

39¢ A POUND, 46

THREE MEN AND A BUGGY, 129

TIDE LAND TAPESTRY, 121

TIDE POOL, 54-55

TOO WET TO FLY, 21

TRAILING SILVER, 31

TRIBUTE, 115

TRICLOPS, 15

TRILOGY, 45

TURBULENT WATERS, 23

UN INSTANT D'ÉTERNITÉ, 38

VINE RIPE II, 40

VISITOR, THE, 81

WABASH STREET, CHICAGO, 107

WATER BALLOONS II, 25

WEBER'S, 133

WHEN I GROW UP..., 82

WHITE LOTUS, 70

WILDFLOWER TAPESTRY, 2-3

Palette knife, 44, 64

Paper

Chinese, 70

cold-press, 31, 36, 48, 67, 88

crinkled, 52

gessoed, 23

gold-specked cotton, 71

heavy Arches, 75

hot-press, 52, 68, 116, 135

Japanese lace, 84

Lanaquarelle, 42, 122

marbled, 84

rice, 56, 61, 63, 84

rough, 44, 55, 63, 104, 126, 130

three-ply bristol vellum, 39

tissue, 63, 84

watercolor, 46

Waterford, 42

wrapping, 63

Pencil

abrasive, ink-erasing, 23

charcoal, 108

drawing, 26

Prismacolor, 46

watercolor, 66, 90

Pigments

matching to subject, 94

mixing, 28

opaque sedimentary, 94

textures of, 42, 64

transparent, 94

Pointillism

reverse, 75

watercolor technique like, 72

Pouring paint, 55

R

Reflections

on apples, 49

creating mood with, 135

on model's face, 86

in water, 16, 21

See also Reflective textures

Reflective textures, 13-31

brass, 126

chrome, 14-15, 18

glass, 20. *See also* Glass

ice and snow, 18

stones, 16, 136-137

See also Reflections

Rust, 23, 26, 58, 133

S

Salt, 16, 26, 48, 96, 102

Sandpaper, 80

Scraping, 56, 67

Scratching, 67, 104

Scumbling, dry-brush, 50

Shadows, 21, 27, 36, 39, 45, 48, 58, 76, 90, 121-122, 135

Sky, 19, 31

Slinging paint, 94

Snow, 19

Soft edges, 19, 37, 41. *See also* Wet-into-wet

Spattering, 26, 39, 42, 50, 61, 67-68, 94, 116

Sponge, 56, 64, 79

Spraying, 61

Stamping, 116

Still life, 98, 136

Stone, 21, 30, 80, 124

T

Textures

animal, 76-77, 84-85, 88-89, 91

asphalt, 133

balancing rigid and relaxed, 41

combining, 50, 131

contrasting, 20, 41, 52, 79, 94, 126

on desert floor, 37

dissimilar, 136

dramatic, 21

fabric, 82, 121

furry, 41

gessoed paper for, 23

of glacier, 24

glass, 102, 132-133

glossy paint, 132-133

granite, 50

layered, 75, 85

luminous, 98

metal, 132-133

mixing mediums for, 56

muted "fresco," 80

of old subjects, 132-133, 135

of people, 72-75, 78-83, 86-87, 90

of Peruvian clothing, 80

plastic, 132-133

rock, 39, 50, 84, 89, 108-109

rough, 30, 94

skin, 86

stone, 80

tree, 44

variety of, 46, 61, 63, 96

velvet, 115

wood, 82, 96, 122

Toothbrush, spattering with, 39, 50

Turpenoid, 46

U

Underpainting, 30-32, 67, 112

V

Value transitions, 94

W

Washes, 23, 28, 37, 39, 70, 104, 124, 133

Washi, 61. *See also* Paper, rice

Water, 16, 21, 23, 28, 31, 49, 119. *See also* Ice; Snow

Watercolors

sedimentary or granular, 52

traditional, 80

transparent, 48, 68

Wax resist, 30

Weather

fog, 112

overcast, 107

rainy, 104

Wet-into-wet, 16, 19, 25, 35, 41-42, 52, 61, 68, 88, 94, 115-116, 124, 126, 128

Wet-on-dry, 25, 94

Whimsical paintings, 116

Whites

bold, 71

gouache, 76, 88

masking out, 31, 39

of paper, 23

for sparkle, 113

specks of, 126

X

X-Acto knife, 46